PASTEL

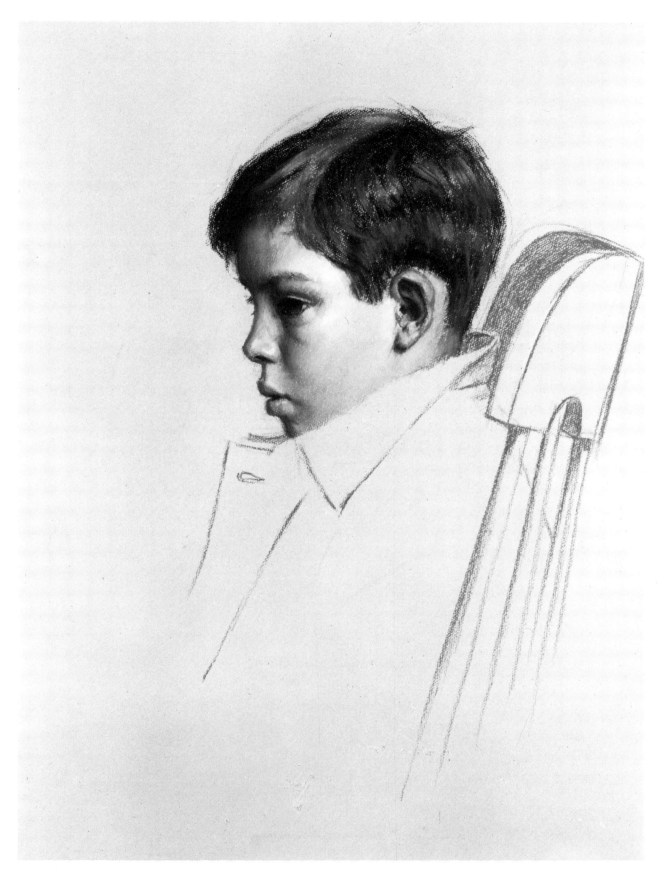

Christopher Adams. *Pastel on paper, 29" × 21". A light tan paper was used to accentuate the dark outline of the head. I posed Christopher in a somewhat flat lighting setup to emphasize the soft, smooth, boyish complexion. (Courtesy Portraits, Inc.)*

PASTEL

BY DANIEL E. GREENE
EDITED BY JOE SINGER

WATSON-GUPTILL PUBLICATIONS/NEW YORK

First published 1974 in the United States and Canada by Watson-Guptill Publications,
a division of Billboard Publications, Inc.,
1515 Broadway, New York, N.Y. 10036

Library of Congress Cataloging in Publication Data
Greene, Daniel E
 Pastel.
 Bibliography: p.
1. Pastel drawing. I. Title.
NC880.G74 741.2'35 74-13740
ISBN 0-8230-3899-8

Manufactured in U.S.A.

First Printing, 1974
6 7 8 9/86 85 84 83

To my daughters Erika and Loren,
two very special people

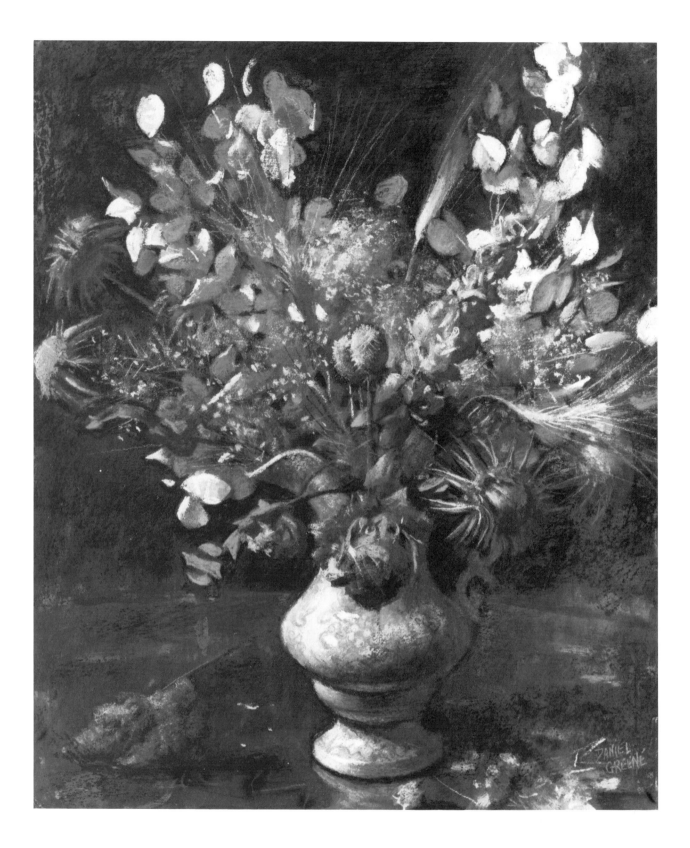

Flowers in a Blue and White Vase. *Pastel on sandboard, 28" × 24". I did the preliminary stages of drawing, proportions, and color accents in acrylic, then broadly blocked in large patterns of light and dark colors. I used pastel to further brighten all the colors, and to model from dark to light throughout the entire painting. The heavy layers of pastel were alternately sprayed with fixative and lightened.*

CONTENTS

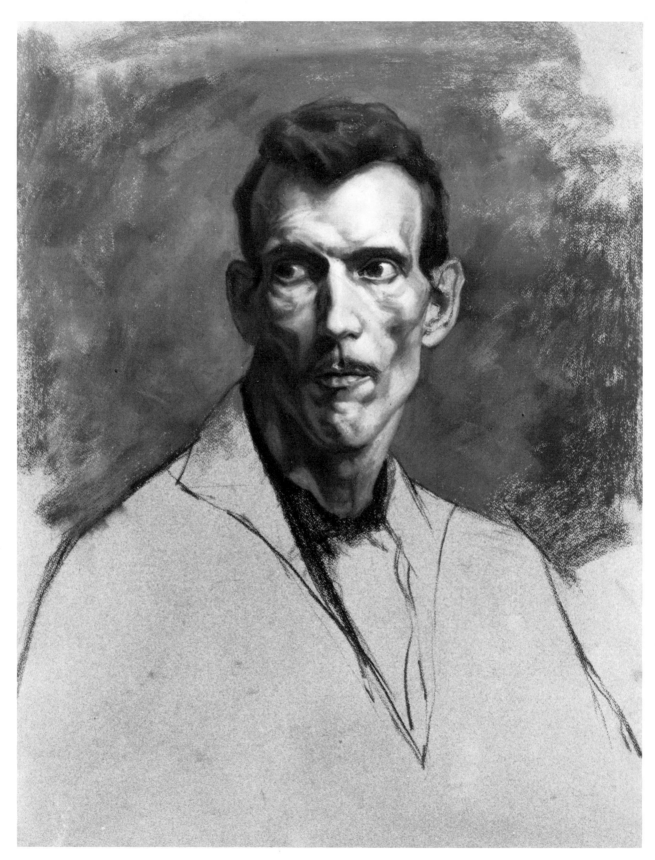

Bill Sutherland. *Pastel on paper, 29" × 21". This is an uncompleted portrait of my friend and frequent model, Bill Sutherland, who can be seen in various costumes in many of my early paintings. Bill is a superb actor who completely assumes the character of the person he is depicting at the moment. Although I have exaggerated or modified some of his features in certain paintings, this is Bill as he really is.*

Acknowledgments

I would like to express my appreciation to Don Holden for suggesting this book to me and for his perseverance in overcoming my reluctance to write it.

Particular thanks to Joe Singer for his patience and invaluable help in preparing the manuscript.

To Tony Mesok of Studio Nine for his superb photography and in appreciation of the many hours of hard work he spent solving the complicated photography problems.

To Andrea Erikson of Portraits, Inc., Jody Kirgeberger of Talisman Gallery, Eve Loring of Loring Gallery, Marge Bobker of Gallery 52, and to Charles and Fay Plohn.

Special thanks to my wife, Jane.

FOREWORD

Pastel has a poor reputation. So many of the works done in this medium have a weak, delicate appearance that pastel has come to mean light, delicate tints. However, pastel is a material with a full range of artistic possibilities. In the hands of a skilled painter with a thorough knowledge of pastel's working properties, a complete range of colors and values, textures and techniques is possible.

Pastel offers a direct approach to artistic expression with a minimum of technical considerations. In this book, I will present my observations of the manipulative qualities of pastel as well as pertinent painting methods. The important areas of feeling, intuition, in-spiration, and taste are personal emotions I shall not attempt to define.

These, when combined with the control of craft, are the ingredients of art. Pastel can obviously be adapted to suit individual styles and tastes. Unlike the vast amount of recorded information available about oils, watercolor, and tempera, little has been handed down on the working methods of pastel. Some great artists of the past have used pastel for brief, spontaneous studies, but only a few delved deeply into pastel techniques. Since pastel has been so neglected, it offers you a marvelous opportunity to explore and invent.

Paavo Giasullo. *Pastel on paper, 29" × 21". Paavo is the son of a village carpenter (who is the figure on the left in the painting called* Trio *on page 34). Paavo happened to visit my studio while his father was being painted and impressed by his fresh, striking, vigorous attitude and appearance, I asked him to model for me. He agreed, and to ease his discomfort somewhat, I decided to let him pose full-face, which would make it easier for me to paint him even if his natural exuberance compelled him to squirm a trifle.*

11

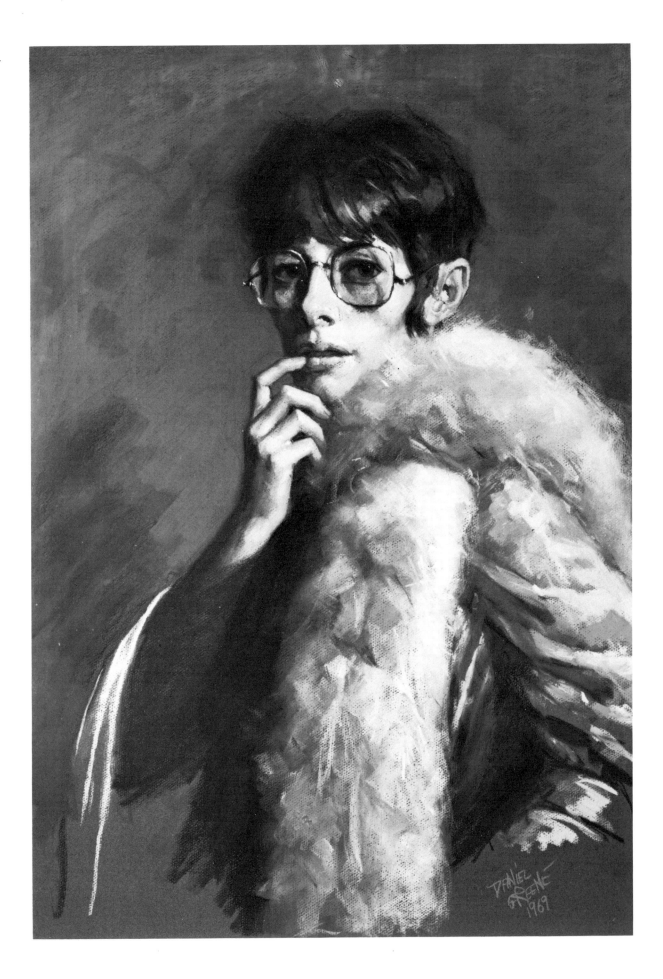

MATERIALS

Nancy in Orange. *Pastel on paper,
29" × 21". The dark brown paper was
selected to emphasize the strong light
pattern of the fur and face — the center
of attention in the painting. The fur could
have been painted more realistically, but
I preferred a rough, chunky quality there
to counteract the many curves in the
picture. I painted the background using
loose broken strokes, to provide an illusion
of freshness and to avoid too smooth and
overworked an impression. (Collection
Mr. and Mrs. Arthur Ufner)*

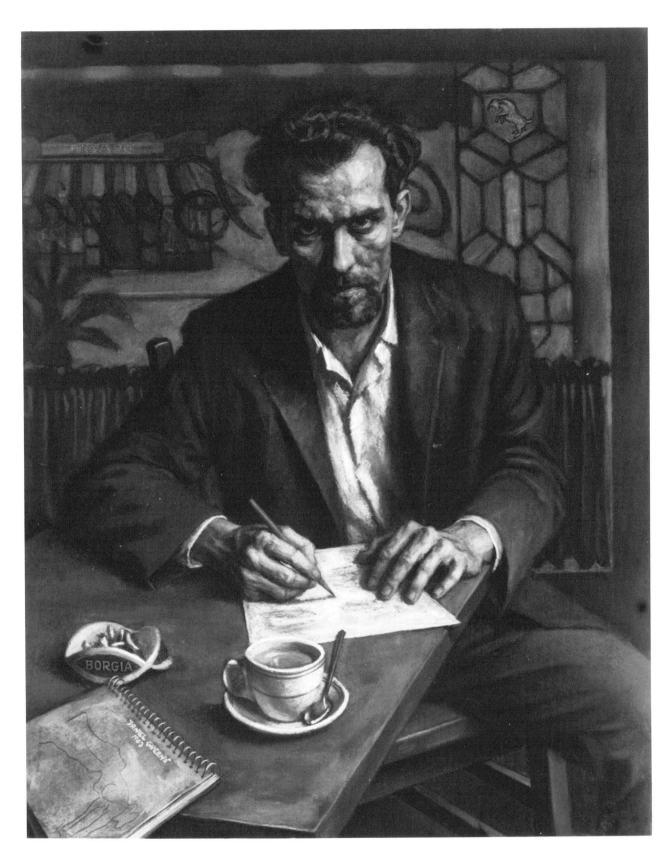

Otto. *Pastel on matboard, 40" × 32". Although this picture was painted in my studio, I arranged the props to simulate a coffeehouse in Greenwich Village that Otto frequented to do his sketching. All the white objects in the painting — the ashtray, paper, shirt, and cup — were done in non-white colors. A soft white was used very sparingly to place a few accents here and there. (Collection Mr. and Mrs. Charles Plohn)*

CHAPTER 1

WHAT IS PASTEL

Pastel is basically raw pigment mixed with a binding agent — usually gum tragacanth — and water into a doughlike consistency, then combined with white chalk for light tints or black pigments for dark shades. This mixture is kneaded into shape or extruded through a tube and cut to a desired length.

Different pigments in pastel require varying strengths of binding solution to achieve the desired consistencies. The strength of the binder, the hardness of the pigment, and the pressure exerted upon the stick during its manufacture determine its degree of hardness or softness. To make harder pastels, a strong binding solution is used and the mixture is pressed into sticks by machine. For soft pastels, just enough binder is added to the pigment to prevent the stick from crumbling when applied to a surface, but not too much binder to prevent it from being abraded by the surface. Some pastels contain an extender, usually talcum or chalk, to make the abrade easily.

Advantages of Pastel. The following are some of the reasons I use and recommend pastel:

Pastel requires little setting-up time; no squeezing out of fresh paint, no premixing of shades and hues. The sticks are all there to pick and choose from and they match exactly the colors and tones used before, since pastel colors don't change once applied.

Pastel can be used on any number of oil-free surfaces; all that's required is a surface with sufficient tooth to shave off and retain the pastel granules.

Pastel can be used as a drawing or as a painting medium, emphasizing either crisp, detailed techniques or a broad, scumbled, painterly appearance. Drawing, blending, direct color, broad or detailed effects, and infinite combinations are possible.

Pastel is a medium that requires no drying time before overpainting. Thus, pastel lends itself admirably to a direct technique, without the laborious pre-planning of paint layers that oils often require.

Pastel requires no additional painting medium such as linseed oil, turpentine, poppy oil, stand oil, water, etc.

Because pastel contains no oily binders, it won't yellow, crack, or form a glossy film that might produce an annoying glare. The easel can be turned to any angle without distracting reflections, and strokes may be made in any direction.

Dust and lint don't stick to a pastel surface as they do to the sticky oil paint surface.

Pastel is a consistently opaque medium that reflects light only from the surface. This eliminates the need that exists in liquid media, particularly oils, to preserve the luminosity of the white ground by carefully controlling the

Green-Gray Nude. *Pastel on paper, 14" × 18". In this silhouette of a light nude figure against a dark background, I deliberately kept the middle-tone and light values extremely close in range. This maximized the effect of a large mass of light fusing the forms together and diminished the definition between the upper arm and breast, forearm and hip, left and right thighs, and the facial features.*

transparency and thickness of the layers of dark colors. Therefore, pastel can be applied over dark and opaque or light and transparent surfaces.

Cleaning up after a pastel painting session is easy — no brushes to wash, no palette to scrape, no colors to be covered.

Pastel paintings require no special aftercare as do oil paintings; the artist needn't keep track of when he has completed each picture in order to have it varnished, cleaned, etc.

When Pastel. For me, the choice of a medium for a specific painting is confined to two alternatives — oil or pastel. I would be more inclined to choose pastel in the following situations:

If the subject seemed suited to a matte, splattered appearance, rather than a liquid, wash-like effect.

If my goal were to establish *immediate* values of light and dark.

If the lighting conditions resulted in a glare on the painting surface: painting outdoors in the sunlight, painting backlighted effects (with the artist facing the light source), or painting in a room with numerous light sources.

If I wanted to paint a vignetted study (a subject without a background), I would use pastel on toned paper.

If I sought a drawn rather than a painted effect.

If the model had to hold an uncomfortable, contorted pose, painting in pastel would be faster and would spare him or her unnecessary discomfort.

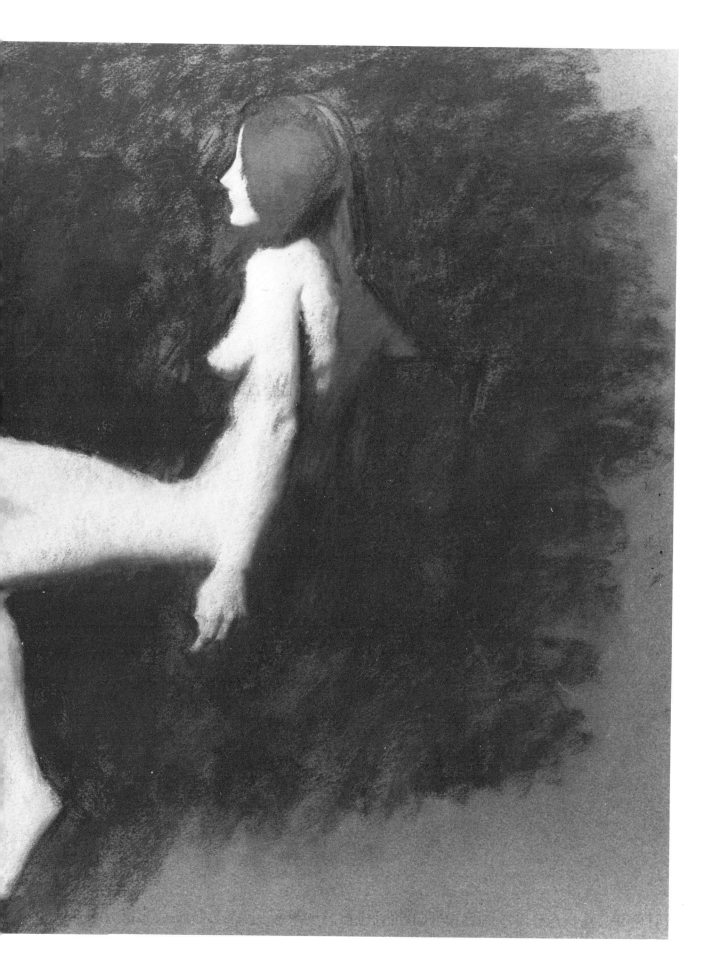

Laila and Friends. *Pastel on paper, 21" × 29". I painted these three youths separately at first, then posed them together at the end. The figure with the glasses was painted somewhat larger, with stronger lights, deeper darks, and crisper edges, to make him seem to advance and make the other two seem to recede. The middle and rear figures were painted in diminishing perspective, with the tops of their hats falling on the viewer's eye level. (Collection Mr. William Smith)*

Alex. *Pastel on charcoal paper, 40" × 32". Alex was a primitive painter and a very colorful and picturesque denizen of Greenwich Village. He insisted on posing with the shell, so I used its sharp, angular shapes to repeat the warm and cool colors of his craggy features and the sharp angles in his hair. I decided to stress Alex's very ruddy complexion by surrounding it with a cool gray background, a cool green shirt, cool tan trousers, and the cool colors of the chair. (Collection Greenshields Museum, Montreal)*

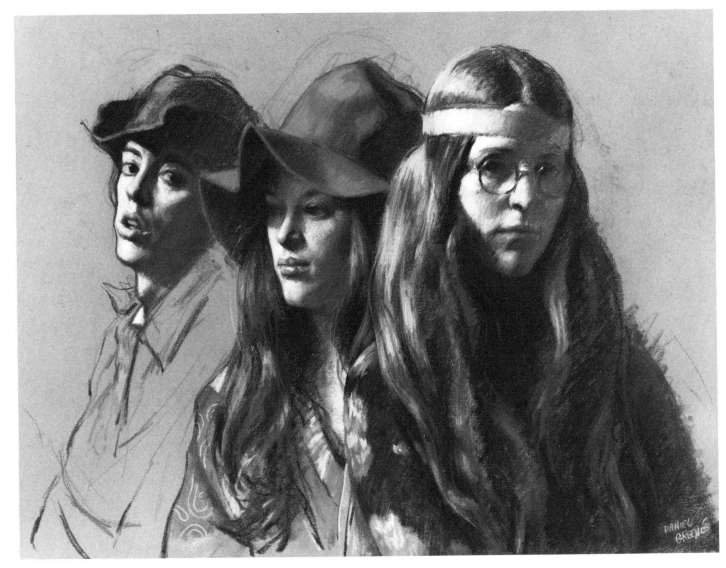

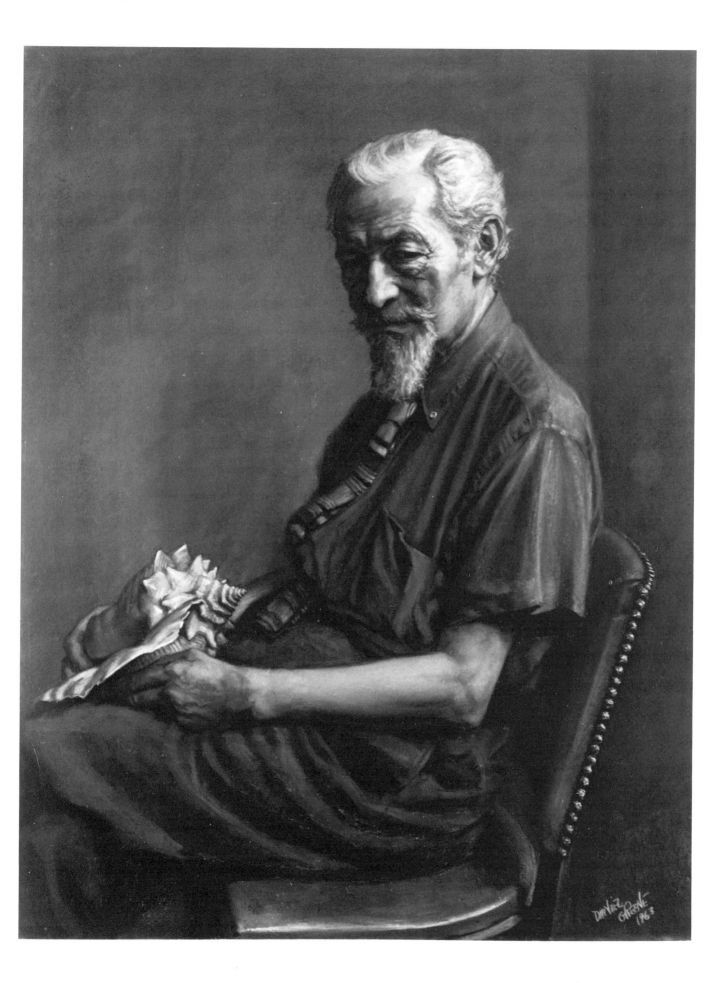

19

Toward Lincoln Center. *Pastel on paper, 21" × 29". Here I used sharpened hard pastels quite extensively. Within the window I laid a very light sky color; to produce a sky that would reflect the greatest intensity of light, I rubbed the area to blend it and to achieve a smooth, flat surface. Over this, I superimposed the buildings with hard pastel. I also used the tip of a hard pastel to render the woodwork details around the window.*

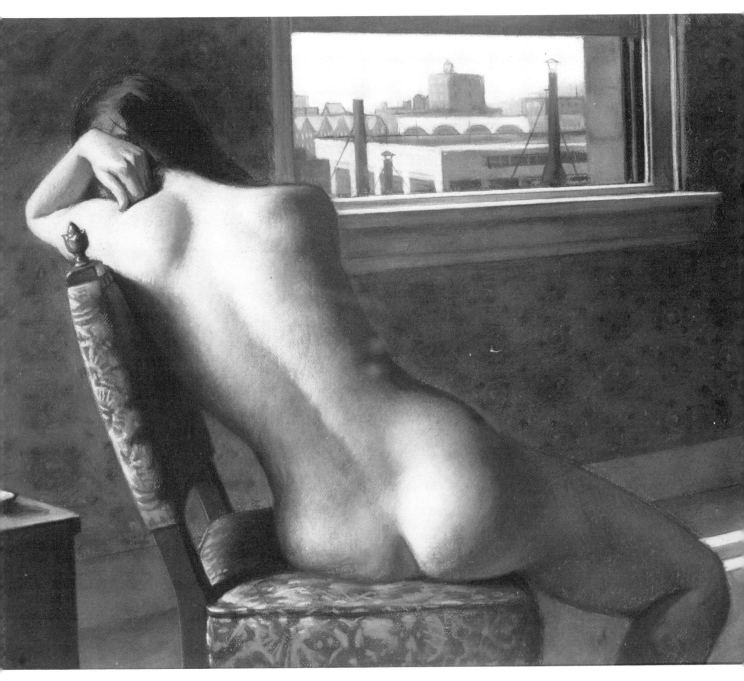

CHAPTER 2

TYPES OF PASTEL

There are three types of pastels you can use — soft, hard, and pastel pencils. Each produces a different textural effect, ranging from soft, splattered strokes to sharp lines. Of course, you can vary the character of these strokes by increasing or lessening the pressure applied to the stick and by choosing a smooth or rough painting surface. In this chapter I will discuss the different kinds of pastel, their characteristics, and when to use them.

Soft Pastels. I recommend that you primarily use soft pastels in your pastel painting; they should constitute the basis of your color assortment. Begin with one basic set of about 300 sticks and build from there. I use the Grumbacher and Rembrandt assortments as my starting point, supplemented by three sets of other brands, each of about 200 sticks. Since gaps exist as to certain hues, shades, degrees of softness and darkness in any individual set, I strongly advise that you buy as many full-range soft pastel sets as possible so that you have exactly the color you need at the time you need it.

Soft pastels vary noticeably from brand to brand regarding the degree of softness. This is due to the difference in binding formulas employed by the various manufacturers. The Grumbacher and Rembrandt pastels are generally the hardest in substance, while the Schmincke, Lefranc, Roget, and the now-combined Lefranc-Giroult lines are progressively softer. By experimenting with your pastels, you can discover for yourself their particular hardness or softness, as well as the textures they produce when subjected to varying degrees of pressure.

Hard Pastels. Hard pastels are generally rectangular, rather than round like soft pastels, and because of their firm consistency they can be sharpened to a point. They're more useful for drawing sharp lines and details than for painting larger areas, but they can be used interchangeably with soft pastels throughout the development of the picture. I use hard pastels to begin my pastel paintings, and use progressively softer pastels as the painting advances. Hard pastels are especially useful in the beginning stages of the picture because they don't crumble excessively and fill the surface tooth of the paper, and so don't build up the painting too rapidly. This allows you to repeatedly overpaint with softer pastels.

When the pressure exerted upon it is altered, each hard pastel stick becomes in effect two sticks — with light pressure, the pastel produces a light tone; with heavy pressure, a darker tone. Hard pastels cover the surface more easily when applied with the shaved tip rather than with the much harder sides or edges. Although I try to keep my hard pastels in one piece, they do break and a special holder is available.

1. *Materials for making pastels: (from back to front) pigments, six solutions of gum tragacanth, masking tape, gum tragacanth powder, mortar and pestle, measuring beaker, syringe, flexible mixing knives, measuring spoons, and glass slab.*

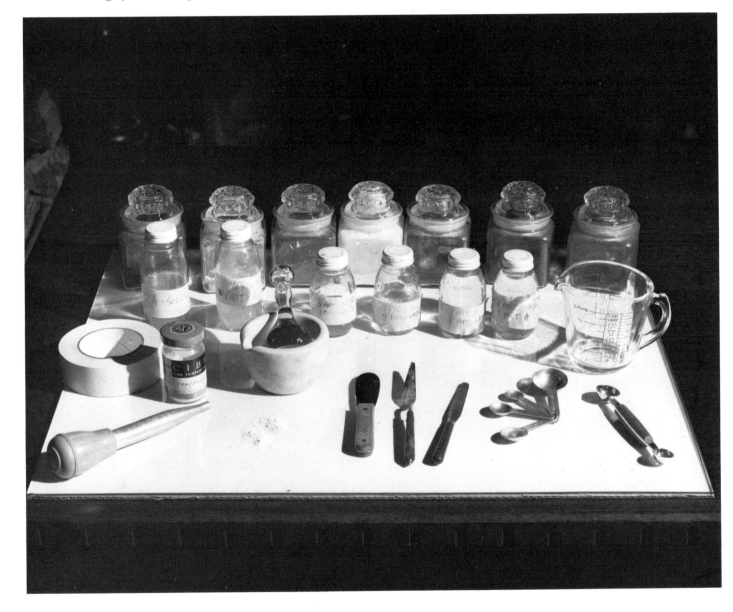

I find that I use the hard pastels more often in smaller paintings because their sharpened points can produce thinner strokes. They also seem to work better on fibrous papers than on rough, granular surfaces.

I favor the Nupastel Color Sticks brand of hard pastels, and these are the colors I use most frequently: No. 223 burnt umber, No. 283 Van Dyke brown, No. 253 cocoa brown, No. 276 flesh pink, No. 204 sandalwood, and white and black.

Pastel Pencils. Pastel Pencils produce sharp, thin lines and I use them only when I can't obtain the same effect with a soft or hard pastel, for example, to strike certain details on small paintings. I recommend the Carb-Othello brand pastel pencils.

What Pastels You Will Need. I have already stated that you should accumulate all the soft pastels you possibly can, beginning with one full-range set as your basis and adding other sets to it. As you work, you'll learn which of your sticks you tend to use up the fastest and you'll be able to anticipate the shortages by stocking up ahead of time. I find that I need to replace the burnt umbers, raw umbers, whites, and dark grays most often. You'll probably also notice that most sets suffer from a uniform lack of sufficiently dark blues, greens, reds, and browns. The Grumbacher selection seems to feature more pure hues while the Rembrandt set tends toward subtler pastel colors. In general, if the bulk of your work will be landscape painting, you can go heavier on the blue and green shades when assembling a selection. For portraiture, the earth tones and reds would be more valuable to you.

In any case, don't let the initial outlay for one, two, or three sets intimidate you. Once the initial outlay has been made, you'll only have to fill in the gaps at a comparatively low cost.

Making Your Own Pastels. A prerequisite to producing your own pastels is a basic knowledge of mixing pigments. Pastels are easy to make and you'll be able to produce your choice of exact shades, consistencies, and sizes. Given a full range of pigments and the necessary time, a complete set can be easily and economically made. The ingredients needed to make your own pastels (shown in Figure 1) are: gum tragacanth, dry pigments, precipitated chalk, flexible palette knives, measuring spoons, mortar and pestle (optional), glass slabs, newspapers, and water. Extensive instructions on making pastels can be found in *The Artist's Handbook of Materials and Techniques* by Ralph Mayer. (See Bibliography.) The basic formula for making pastels is: Mix a weak solution of gum tragacanth and water. To form a white stock, add precipitated chalk and knead until it forms a "dough"; to make a black stock, mix gum tragacanth solution with black pigment. To make colored sticks, grind pigment, then mix measured proportions with gum and chalk mixture, kneading until the white streaks disappear.

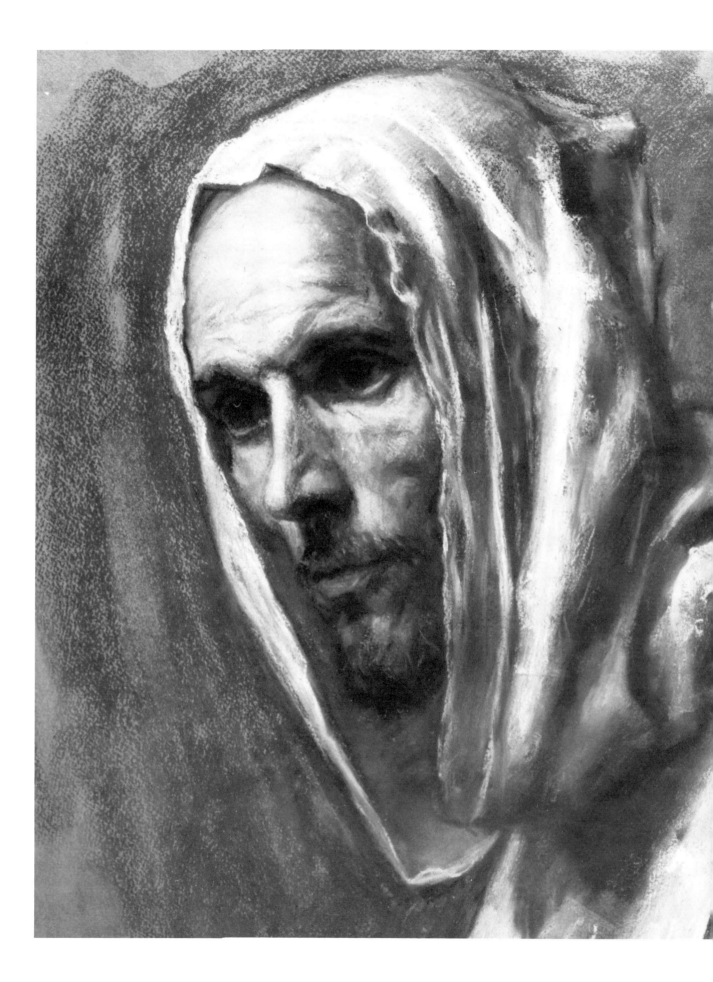

White Monk. *Pastel on paper, 20" × 28". I painted much of the robe and background with the sides of soft pastel sticks. The folds in the cloth were first registered in large, dark masses, then individually picked out with middle tones and lights. Wherever necessary, the darks were then again reinforced. (Collection Mr. and Mrs. Charles Plohn)*

Mark and Peggy. *Pastel on paper, 21" × 29". This was a rapid study executed in one sitting. I used brown Nupastel for all the darks and left much of the tan paper to serve as the middle tones. Soft pastels were used for the light areas. (Collection Dr. Mark Krugman)*

Rita. *Pastel on paper, 29" × 21". Only soft pastels were used throughout. First the darks were roughly placed in the face and hair. Then I chose raw umber for the facial middle tones, ochres and pinks for the lights in the skin tones, and orange and gold for the lights in the hair, as a contrast to the wine-red paper and the umbers in the skin. Notice that the strokes in the face are painted against the outline to achieve broken, jagged shapes rather than exact, precisely drawn lines.*

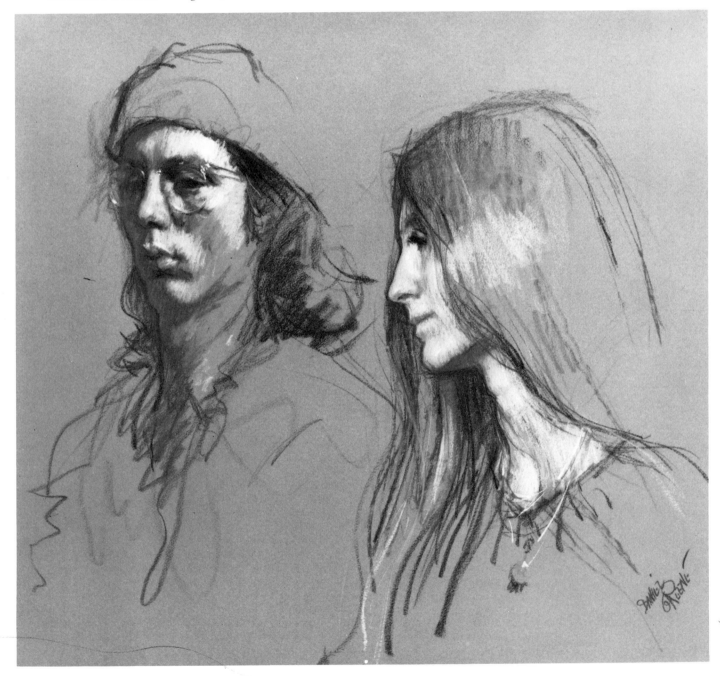

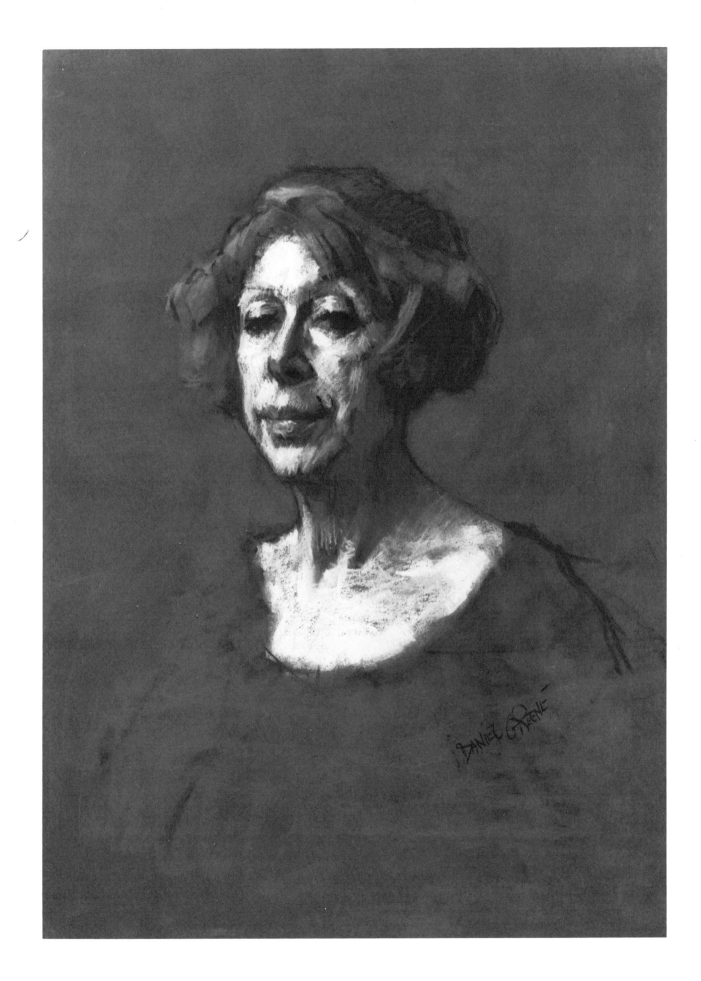

Nude on Tan. *Pastel on paper, 18" ×
16". A rapid study in which the color
and tone of the uncovered and partially
covered paper were employed throughout.
The lighter colors were scumbled lightly to
half cover the paper, and to serve as a
middle tone connecting the lights and
darks. Soft charcoal was used for the darks
and partly wiped away with a stump.*

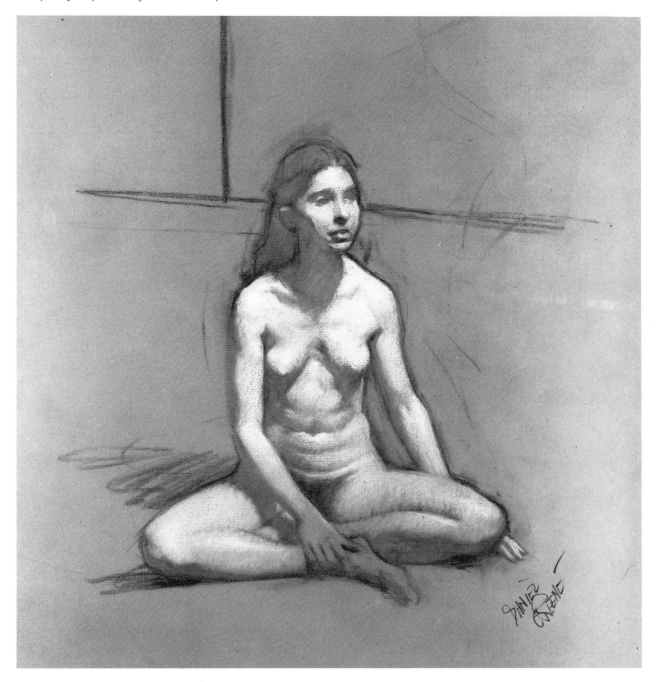

CHAPTER 3

PASTEL SURFACES

Pastel may be used on a great variety of surfaces, but paper and granular boards are the most commonly used.

Paper. I do most of my pastel painting on paper. When choosing a paper, I consider these factors: tooth, tone, color, size, strength, and permanency. (100% rag paper is best for pastel painting because of its durability.)

Tooth. The texture of a paper (its peaks and valleys) is called *tooth*; pastel may be used on both smooth-textured and rough-textured paper.

Smooth paper has less tooth than rough paper; when you pass the pastel stick over smooth paper, it shaves off fewer pastel granules. The pastel also lies more closely and evenly distributed over the surface and builds up more rapidly, resulting in a heavy impasto or paint layer. Additional applications of pastel are more difficult since the pastel stick tends to slip right over the evenly built-up surface. Smooth paper has little or no visual effect on the final painting since its tooth is too minute, and it's best suited to paintings with sharp, even lines or fine details.

Rough paper has wider and more distinct peaks and valleys that shave off more pastel granules than smooth paper; however, the granules build up more slowly in the wider tooth, so you can work more layers of pastel over the same area. Pastel adheres more firmly

to the rougher tooth and is less apt to be dislodged during framing, handling, etc. Pastel on rough paper has a soft, grainy appearance that can be scintillating and artistically interesting.

Tone. On a white surface, light colors and tones never seem light enough until they're surrounded by darks. So, by beginning your painting on a middle-tone ground, you eliminate the need to constantly readjust all the light colors as the painting progresses. Using a toned ground also facilitates the natural progression of the painting (from dark to light) by striking the proper tones at the very start.

I use the Canson Mi-Teintes brand paper for most of my pastel paintings on toned paper. There are three basic tonal ranges from which I select my paper tone for a particular painting — light, middle, and dark.

Light tone papers are best for pictures stressing dark tones. Since most pastel colors will be darker than a light tone paper, this allows the widest selection and the fullest use of dark colors and values. Among the light tone papers in the Canson Mi-Teintes line, I find the following papers most useful: No. 343 gray, No. 480 pale green, No. 331 tan, and No. 354 blue-gray.

Middle tone papers are best for most pastel work since they represent a median from which the artist can proceed to the lightest and

darkest limits of the pastel color range. The following papers are most useful in the middle-tone range: No. 345 medium gray, No. 429 warm gray, No. 431 cool gray, and No. 502 ochre.

Dark tone papers are useful when you wish to emphasize light areas in a painting. However, since there are noticeable gaps in the darkest colors in most pastel sets, it may be wiser to avoid working on dark-tone papers until you accumulate enough dark colors to be able to achieve dark tones on dark paper. Many of the seemingly dark colors in pastel sets look much lighter when used on a dark paper. Among the dark Mi-Teintes papers, I find No. 501 brown the darkest (excluding black). Other useful dark-tone papers are: No. 448 green, No. 500 blue, and No. 503 maroon.

Color. A wide selection of colored papers is available — at least 30 in the Mi-Teintes line. There are several reasons for choosing a colored paper. You may want to select a certain color to serve as either a contrasting or a complementary base for your painting. In a painting of a ruddy-faced man you may want to use a cool green or gray surface for color contrast. In a painting of a person with a fair complexion, you might select a warm orange or reddish tone to accent the cool colors of the skin.

A colored paper that matches the general background of a picture, such as the color of the wall behind the sitter, makes it easier to match values and colors in the painting itself. In a vignetted painting you might use a paper similar in color to that of the subject, so that the paper provides the basic, overall middle color with only the highlights and shadows

needed to finish the painting. (This was a common practice in certain Renaissance charcoal drawings where the artist merely added white to the toned ground for the lights.)

It's best to avoid bright, strongly colored papers, since they will affect your choice of pastel colors while painting. For example, a cool color on a bright green surface would lose its natural cool character and seem neutralized or warm by comparison. A bright, pure-hued surface sets a color range that requires equally bright pastel hues, of which there are only a limited number.

If I need a sheet of colored paper larger than the standard 21½" × 29½" size, I cut it from the 11 yard × 51" Canson Mi-Teintes roll, which is imported by the Morilla Company (43-01 Twenty-first Street, Long Island City, New York 11101). Cutting an individual sheet from the roll requires careful handling since the roll must be weighed down (to prevent its curling up) and the paper is liable to rip in the process. There are two ways to flatten the paper to rid it of its curl: one is to cut the size sheet you want and then to take it to a frame-maker who will mount it to a rigid backboard with a large mounting press; the other is to iron the paper yourself *before* you cut it away from the roll.

Ironing Your Own Paper. The procedure for ironing your own paper (which requires two people) is as follows:

1. Find a large flat surface to work on, preferably one raised from the ground such as a model stand, and pad this working area with newspapers or several bed sheets.

2. Place the roll, curled side down, on this

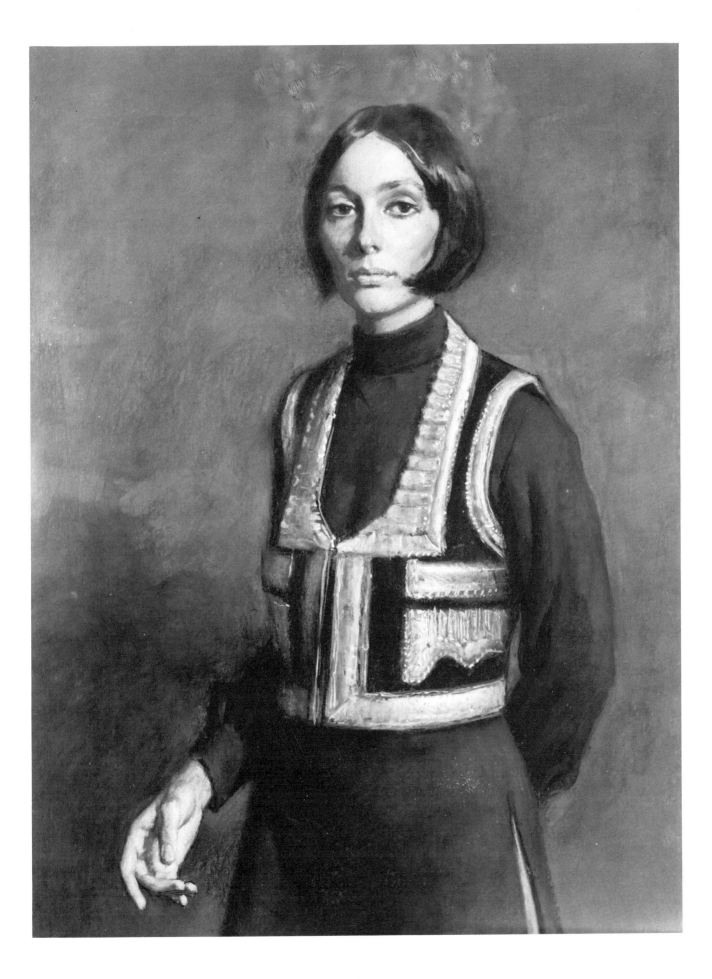

Nancy. *Pastel on paper, 14" × 18". Here I used the paper for all the shadows and used pastel only to strike the lights. By exerting light pressure on the pastel in the areas lying between lights and shadows, I produced a broken, scumbled texture to serve as the middle tone. Some crisp, strong contrasts within the lights and sharp edges in selected areas give the impression of advancing and receding planes and of lighter and darker shadow values.*

Jo Ellen. *Pastel on paper, 8" × 12". The tone of the gray paper was employed as an additional color throughout the picture. I used a stump to blur the initial massing of the hair and to soften and blend the skin tones into the chest. The somewhat thicker layers of pastel in the head were first manipulated with the stump, then gone over with fresh, direct, final strokes to minimize the blended character of the tone in that area. Rough accents were also used to contrast with the blended areas in the rest of the picture.*

Trio. *Pastel on matboard, 40" × 32". I painted this large composition on a smooth, green board without roughening the surface in any way to make it more conducive to pastel. After the first layer of pastel, the surface became easier to work on. This painting is essentially a study in contrasting colors, types, and expressions. If I were to paint it today, I would rearrange the composition, however I include it here since I consider the Harlequin's head one of the most successful I've ever painted. (Collection Mr. and Mrs. Charles Plohn)*

flat surface and have your partner hold it firmly in place.

3. Set an ordinary house iron to its coolest temperature. When the iron is ready, run it along the area of the paper you wish to flatten. Make sure you keep the iron perfectly flat on the paper, so the heel doesn't dig into the paper. Maintain an even pressure on the iron and keep it moving at all times. Overlap your strokes so that no area is left uncovered, and iron an area somewhat larger than you will be cutting.

4. Cut four sheets, lay them on the floor, and trim away the excess paper with a metal ruler and single-edge razor blade.

5. Clamp the sheets to a piece of plywood with the curled side under to negate any remaining tendency to curl. As you attach the clips, run your palm over the sheets to smooth out any wrinkles.

Durability. Mounting a sheet of pastel paper to a rigid backboard combines the textural advantages of the paper surface plus the strength and durability of the board. Generally, the thicker, smoother, and more rigid the support board is, the better the total unit will resist damage and wear and tear. The ultimate permanence of the painting will depend on the quality of both the paper and the backboard. A 100% rag board is best.

You should mount your paper before you begin painting, because afterwards the painting can be easily smudged during the mounting process. The best method is the dry mount, available at some framers. The paper is cemented to a board with heat-soluble glue by a large mounting press.

Mounting Your Own Papers. To mount papers yourself, you can use any of the various water-based glues — library paste, starch paste, or gum tragacanth. The procedure is very simple:

1. Cut a smooth, even board (preferably 100% rag content) to the *exact size* you want your picture to be. Cut the paper a bit larger than the board so it overlaps on two adjacent sides.

2. Using a 3" wide brush, apply the glue to the paper, the boards, or to both. Tack down the paper temporarily with masking tape to keep it from sliding while you apply the glue.

3. Before the glue sets, lay the board (glued side up) on a smooth, flat surface, then center and align the glued paper along *one edge of the board*.

4. Press these aligned edges together while holding the other, loose, end of the paper up in the air to keep it from adhering, in case the alignment needs adjustment. Then, when the paper seems properly aligned, press the other end of the paper to the board, and go over the whole paper with an ordinary house-painter's roller to smooth out any bubbles, creases, or wrinkles.

5. Once the paper is lying smoothly in place, turn the unit over so the board is on top, and trim off the excess paper with a single-edge razor blade.

Some Additional Notes. Although both sides of the Canson Mi-Teintes paper are perfectly usable, I prefer the side that's more blotter-like in texture. The other side possesses a somewhat linear, repetitious pattern. This is a minor point but I find the blotter-like side

less uniform and monotonous, allowing a greater variety of textural effects.

When using paper, particularly thin paper, pad it with five or six other sheets underneath to provide a more spongy and sympathetic working surface and to avoid picking up the character of the underlying support board.

One disadvantage of using paper is that when framed, sheets larger than 20″ × 24″ may buckle and fall forward against the inside of the glass within the frame.

Other Papers. In addition to the specific pastel papers such as the Canson Mi-Teintes line, it's possible to use other papers which aren't exclusively designed for pastel painting. This includes charcoal papers, although I find their regular, linear tooth makes them less than ideal for pastel. Charcoal paper is also too thin and fragile for vigorous pastel manipulation.

Watercolor papers can be used for pastel, preferably the rougher-textured ones. It's best to tone these papers, which are white, before painting.

Cardboard is a possible surface for pastel, however it's generally too smooth and impermanent for serious work. Besides, the texture of cardboard (widely separated lines) is very prominent in appearance.

Additional papers you might consider for pastel painting are rice paper, velour, and sandtextured papers.

Boards. Another excellent ground for pastel painting is the granular board. Two of the most satisfactory granular boards are the sand and the marbledust surfaces prepared on a good, 100% rag board. Other granular surfaces can be made up using grades of pumice, silica, or quartz.

Sandboard. Commercial sandboard comes in fine and rough finishes; I prefer the Grumbacher rough-finish board. The sandboard can be cut down from its 24″ × 28″ size and toned to a desired shade with acrylic, gouache, casein, or watercolor paint. It won't buckle like paper, but its rougher surface requires a less fluid, more scumbled and splattered pastel technique. So, since the rough tooth results in an irregular stroke, sandboard isn't as good as smooth paper for detailed work. Blending pastel and covering large areas are harder, and it's also more difficult to assess and adjust the pressure you're exerting on a pastel stick. To fill this rougher tooth, you'll have to use the side rather than the tip of the pastel stick. Of course, the rougher tooth also holds more pastel than paper does, so you can develop multiple pastel layers.

Marbledust Board. Marbledust boards are no longer commercially manufactured, so you must make your own. It requires a little effort, but I find the resulting surfaces sufficiently exciting to justify the effort. Marbledust is sold in packages or jars by H. Behlen & Brothers, Inc., P.O. Box 698, Amsterdam, N.Y. 12010. You'll also need a can of fixative and some 100% rag illustration boards cut to the size you desire (Figure 2). (Incidentally, the thicker such a board, the better it will serve your purpose — providing your painting with rigidity and stability.)

My procedure for making marbledust boards is as follows:

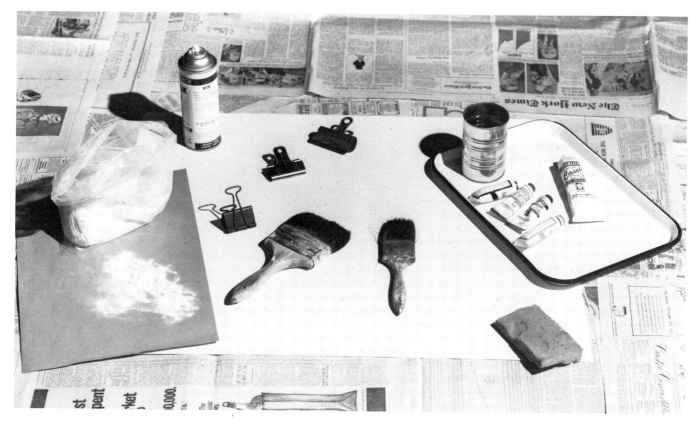

2. *Materials for toning boards and preparing granular surfaces: (from left to right) marbledust, fixative, clips, brushes, casein colors, enamel tray, sponge, and 100% rag board.*

1. Mix acrylic paint of the desired colors with water in a can or other container; sprinkle a quantity of marbledust into the paint and stir.

2. Lay the board on a flat surface; with a 3″ wide brush, stroke the paint mixture onto the board, covering it completely. While the surface is still wet, sprinkle more marbledust onto the board until it's as rough as you want it.

3. Spray the board with enough fixative to glue the particles to it. At this point (while the board is still slightly wet) I usually pick up the board and strike it against the floor to dislodge any loose granules. If I need more tooth, I sprinkle on more marbledust and spray again with fixative.

Another method is to sprinkle the marbledust onto a board coated with a strong solution of wet gum tragacanth. When this dries, brush on a tone of acrylic paint containing additional marbledust. Library or starch paste may be substituted for the gum tragacanth.

If you scrape away an area of a marbledust board or a sandboard for correction while painting, you can sprinkle additional marbledust over the bald or disturbed area, then glue it into place with fixative. In fact, you can add marbledust with fixative at any time during the painting.

Marbledust can also be added to a sandboard since the two substances are inert and completely compatible.

Toning Boards. When I want to tone a board — I don't tone paper since it's available in so many shades and also buckles from the aqueous medium — I generally use acrylic or casein paint. I dilute the paint with warm water until it has a thin, watery consistency. Laying the board on a flat surface, I use a 3″ wide housepainter's brush or a sponge to apply it. By experimenting, you'll discover what proportions of paint and water to use to attain the tone you desire.

Depending on the effect I'm after, I cover the board in either an even or a broken tone. The rougher the tooth, the more difficult it is to apply the tone evenly and the larger the quantity of paint and water necessary to cover it.

Immediately after I've toned one side of the board, I wet the reverse side with water and clip the board to a support board to prevent its buckling while drying. Both light and heat will accelerate the drying time of your toned board. Remember that water-based paint, especially casein, tends to dry lighter than it appears when wet.

I use tube colors only. Here are some color combinations you might use to tone your own boards:

1. Black thinned down with water, resulting in a pale, silvery gray.

2. Black mixed with cadmium yellow to produce an olive green.

3. Raw umber diluted to a tannish gray.

4. Alizarin mixed with viridian green to produce either a gray-green or a maroon, depending upon which of the two original colors is predominant in the mixture.

5. Black mixed with raw sienna to produce a brown ochre.

6. Viridian and raw umber mixed to produce a dull green, a green-brown, or an olive, depending upon the proportions used.

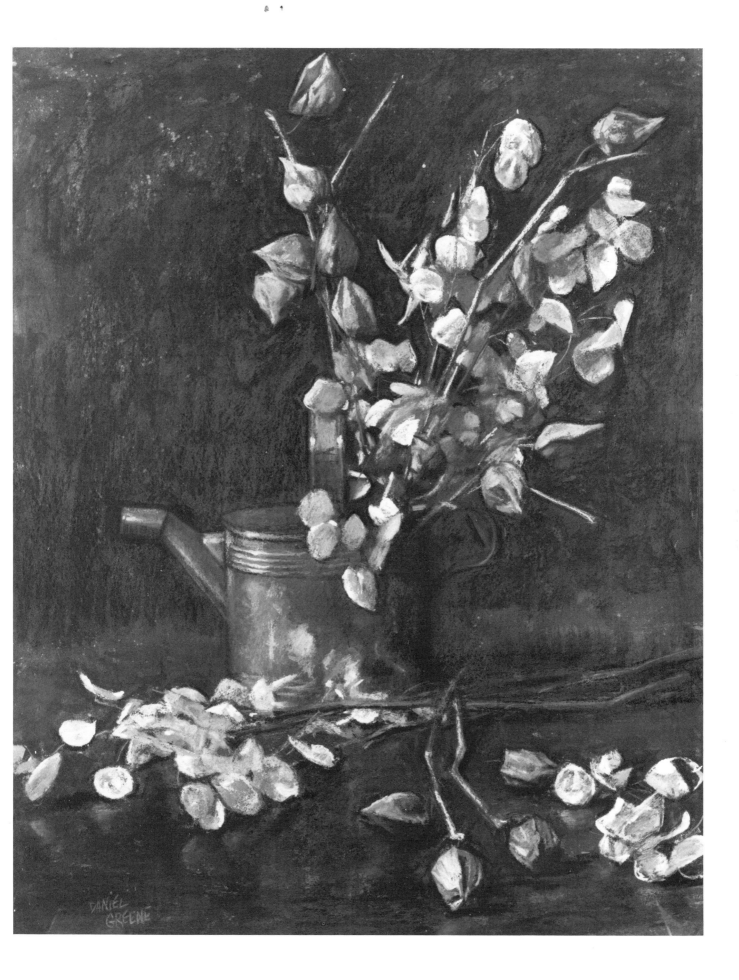

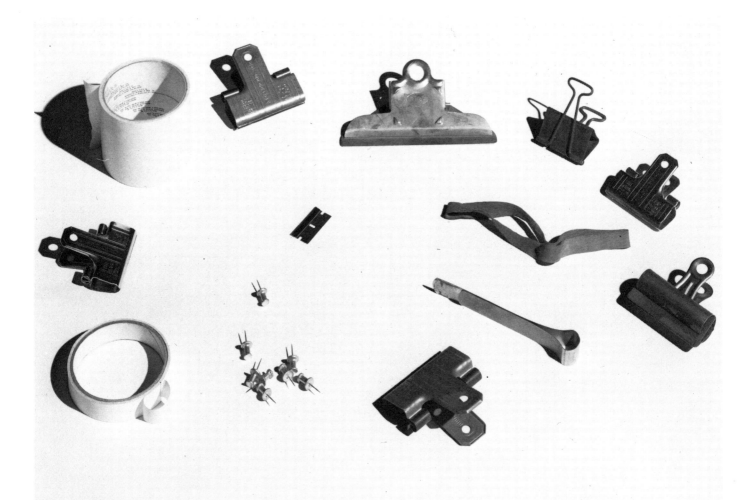

3. *Materials for attaching paper or board to a backboard: assorted clips (the folding prong kind are particularly useful because they fold back to form a flat head), masking tape, pushpins, single-edge razor blade, and large rubber band.*

Other Surfaces. Although I seldom use anything but paper and granular boards for my pastel work, there are other surfaces you could use with good results.

Canvas is a widely recommended surface for pastel painting. An unprimed canvas is preferable since the oil content of a primed canvas somewhat repels the pastel. To provide a rigid working surface, the canvas should be tautly stretched to the size you want, with a piece of cardboard placed between the surface and the stretchers. Pastel canvases are manufactured by Grumbacher.

You should avoid the so-called canvas boards — cloth glued to pasteboard — because of their impermanence. Other possible, if less commonly used pastel surfaces, are parchment, linen, muslin, vellum, and flocked paper.

Attaching the Painting Surface to Your Support Board. A drawing board that is 1" larger on each side than your paper or board is the best size support. Before attaching a paper, place five or six extra sheets underneath the top sheet to provide a softer, more yielding surface. A board, naturally, requires no such padding and can be attached directly to the drawing board with clips. Avoid using masking or other tape on pastel papers or boards since these may tear the painting surfaces. Instead, use wire-pronged clips to attach the paper or board to the support board.

I tilt the top of my painting toward me when working, so I also use a large ½" wide rubber band to hold the paper or board flush to the bottom of the drawing board. When it comes time to work on the bottom area of the picture, I remove the rubber band and replace it with clips or pushpins. (See Figure 3.)

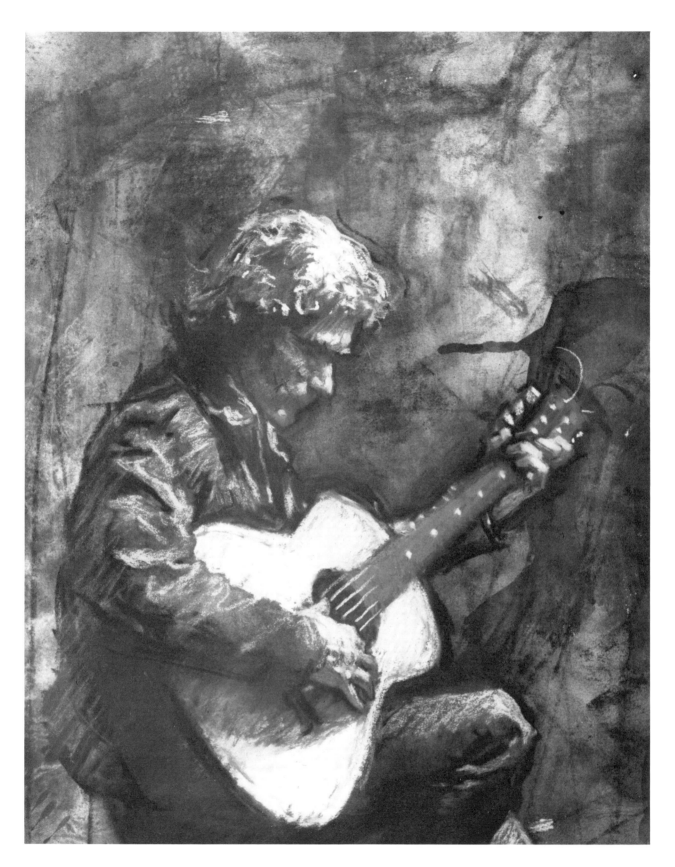

Jon Playing Guitar. *Pastel on watercolor board, 10" × 8". The watercolor board used in this painting was toned well in advance of the actual beginning of the picture. The abstract patterns in the background dictated the placement of the figure. I was careful to draw the figure precisely so as not to disturb the background with extraneous strokes of pastel. (Private collection)*

CHAPTER 4

EQUIPMENT

In this chapter, I'd like to discuss some equipment, methods, and materials that may ease your pastel painting efforts.

Drawing Board. The most important function of a drawing board is that it offers a firm, immobile support for your pastel painting surface. The commercial wooden drawing boards sold in art supply stores are fine, but I prefer the lighter-weight hardboard, Homasote, Celotex, or other wallboards available in lumberyards. They are lighter and easier to handle and can be cut to fit your needs. I recommend that the support boards be 1″ wider than the painting surface on all sides. This 1″ border makes it easy to clip the paper to the support board and prevents the paper from crushing or buckling when the board is fitted onto the easel. You can have many such boards made up in the standard pastel sheet sizes, or the surface sizes that you most commonly use. I keep at least 12 such different-sized drawing boards handy in my studio to meet any painting contingency. It's better than having to remove unframed pastels from a board when you need a new support in a hurry. Even if you paint on granular pastel boards, which are stronger than paper, it's still best to support them with a drawing board for extra firmness and rigidity.

When buying support boards, make sure they aren't too thick for the clips you'll be using or to fit easily onto your easel. They should also have a smooth surface so their texture

doesn't affect your paintings. The corners of the board should be perfectly true and squared, so you can use the edge of your board as a kind of T-square to align your paper and to check the straight lines and angles in your painting. You can also realign the board from sitting to sitting by comparing the edge of the board against some straight line such as a corner or window frame in your studio.

Easel. Any easel will do for pastel work providing it's sturdy, stable, can be raised and lowered, and tilted backward and forward. Since pressure is such a vital part of pastel painting, it's particularly important that your easel doesn't wobble or skid when you're pressing down on your paper. The easel should also be high enough to hold your board at eye level if, like me, you prefer to work standing. An easel with a sliding or ratchet top bar is essential to allow the top of the drawing board to be firmly braced. Try to avoid letting the bar touch the paper and possibly make it buckle.

For outdoor painting, I prefer the portable, folding French easel, which offers solid support even in a moderate wind. For studio painting, I find it helps to have the easel mounted on casters provided it's heavy enough to remain in place while you're working.

Taboret. A taboret is a piece of furniture, usually a table, on or in which painting materials are stored. There are as many kinds of

taborets as there are artists; choose one which will best serve *your* needs. Your taboret should be big enough to hold all your pastels and whatever additional materials you might want at arm's length while painting. If your taboret is rimmed, all the better — the pastels won't roll off and break. Mounting the taboret on casters also provides easy mobility.

My taboret is a large sheet of plywood 53" × 26" × ¾", rimmed and permanently mounted on an old sewing machine base set on casters. It's about 30" high, which is handiest for me, when I work standing. If I were to sit, I'd set it about 18" high.

How to Lay Out Your Basic Pastels. As I've already mentioned, I buy the largest set of soft pastels available in any one line, which might total about 300 sticks. These usually come in a tiered box of three removable trays grooved to hold all the sticks separate from each other. Keeping the pastels in the same order in which they have been packed, I take my basic set (either the Grumbacher or the Rembrandt line) and lay out the three trays on my taboret. I place the least-used tray, consisting of the green and blue colors, in the rear, and the other two trays of the more frequently used colors closer to me in front (Figure 4).

I then remove each stick from its groove, mark its number in the groove with a ballpoint pen, and replace the stick. This way I know where each stick belongs when I replace the sticks before the next painting session. Most manufacturers pack pastel sticks according to hue (greens, blues, etc.). When the sets are not separated this way, I rearrange them and *then* mark the grooves.

To break a pastel stick — which I do only

when I need a piece for a wide stroke — I snap the stick in half with both thumbs and forefingers, then pull the desired piece out, leaving the numbered paper jacket intact. As the work proceeds, I try to replace the broken pieces either within their original jackets, or in the appropriate groove.

On either end of my taboret I keep extra sticks of those colors I use most frequently. I also keep there my pastel pencils, erasers, razor blades, charcoal, paper towels, fixatives, and other materials I might need during the session. I place the hard pastels close to me for easy accessibility and reserve the very nearest space on the taboret for the pastels I'm currently using and for my mahlstick.

Before painting a new picture I work on my taboret and try to replace as many sticks in their grooves as possible. This is very important, particularly for the novice pastelist, since one of the most difficult problems in pastel painting is learning how to find the right stick at the right time. Beginning with most sticks in their correct places expedites this constant search and selection. Of course, if you're going to continue on the same picture in the next session, you can leave out the sticks you've been using without replacing them in the trays.

Using Additional Pastel Sets. As I've already mentioned, you might find that your basic set of pastels lacks sticks that are sufficiently soft, dark, bright, etc. To overcome such deficiencies, I buy six complete sets from six different manufacturers, and replace one set with another. I simply put the next set right on top of the basic set — tray over tray — and continue my work. I try to keep each set orderly as a unit and not mix it with the other brands. As you

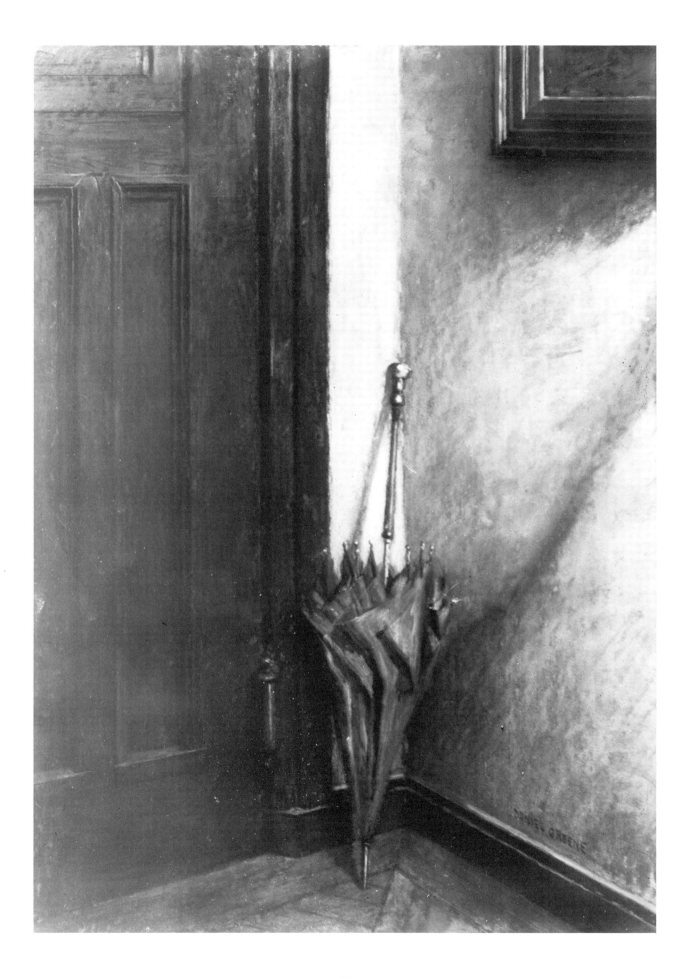

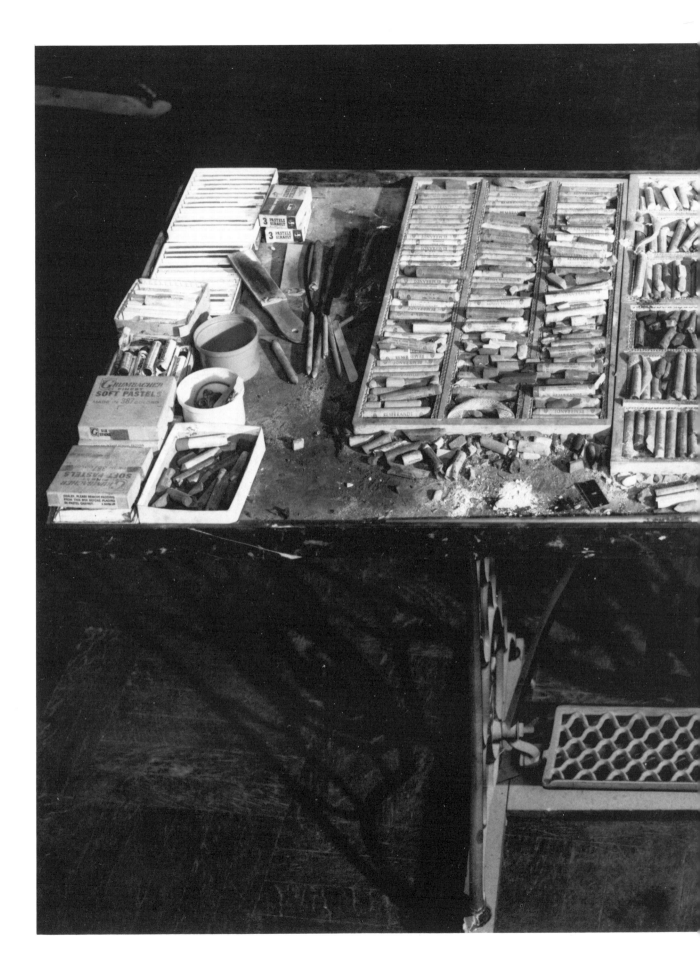

4. My taboret is a piece of plywood mounted to an old Singer sewing machine base set on casters. Strips of wood are nailed around its perimeter to keep the sticks from falling off. The taboret holds three sets of Rembrandt pastels in the middle; assorted boxes of the most frequently used hard and soft pastels, charcoal, stumps, and erasers on the left; boxes of favorite colors, Carb-Othello pastel pencils, assorted hard pastels, fixatives, and mouth atomizer on the right; and razor blades, drawing materials, and mahlstick in front.

paint, you should progress from the darkest to the richest, brightest colors, and from the hardest to the very softest pastel sticks.

Other advantages of switching to a new set of pastels are that the softer consistency of the new set makes the application of the pastel easier, and that there is a psychological boost in having a complete, clean, fresh set available at your fingertips.

Fixative. One of the most valuable tools to extend technique is fixative, a thinly diluted varnish that is sprayed or blown onto the pastel surface. You can use fixative to secure the pastel particles to the surface, repair an erased pastel surface prior to repainting, darken certain areas so they can be reworked in lighter colors, dip the pastel sticks so the pastel spreads more thickly and plastically, adhere pumice, sand, or marbledust to the painting surface, and fix the final painting before framing.

My spraying procedure in the intermediate stages is as follows: leaving the paper or board in a vertical position, I stand about 3' away and aim the spray to the side of the painting to test the density and velocity of the spray. When I've regulated the spray, I gradually aim it onto the painting area, moving the spray in a circular direction while maintaining a steady pressure so no part of the painting receives an excess of fixative. To fix the pastel particles to the surface, I spray until I notice an area darkening, then stop. To deliberately lower the value of an area, I continue spraying until the area is sufficiently darkened, keeping in mind that the pastel will appear darker when wet than when dry. For small areas, I use a mouth atomizer and a bottle of fixative instead of a spray can. I always pass a piece of picture wire through the atomizer immediately after using to prevent clogging.

If you haven't had much experience with fixatives, I suggest you take some scraps of pastel paper, apply pastel to them, and test degrees of change produced by using fixative. See if you can maintain a steady light, medium, and heavy pressure and notice what happens to the pastel surface after you've fixed it lightly and heavily. Rework with pastels and spray again, experimenting with lighter and darker colors.

Formulas for making your own pastel fixative can be found in *The Artist's Handbook of Materials and Techniques* by Ralph Mayer and in *The Materials of the Artist and Their Use in Painting with Notes on the Techniques of the Old Masters* by Max Doerner. (See Bibliography.) The advantages of homemade pastel fixative are that it evaporates quickly and doesn't darken appreciably and so it's best used for the final fixing before framing. (Figure 5 shows the materials used in making your own fixative.) However, while painting, I like the spray can fixatives better, since their darkening qualities are precisely what I'm after. I use the Weber Pastel Fixative and the Grumbacher Tuffilm Spray Fixative.

Additional Painting Materials. Here are some materials that you might want to keep handy on your taboret:

Erasers and Razor Blades. Try to avoid erasing pastel since erasing destroys (or at least alters) the painting surface. However, when you must erase, use a single-edge razor blade and a kneaded or gum eraser. (The kneaded one is best, since it's pliable and can always be

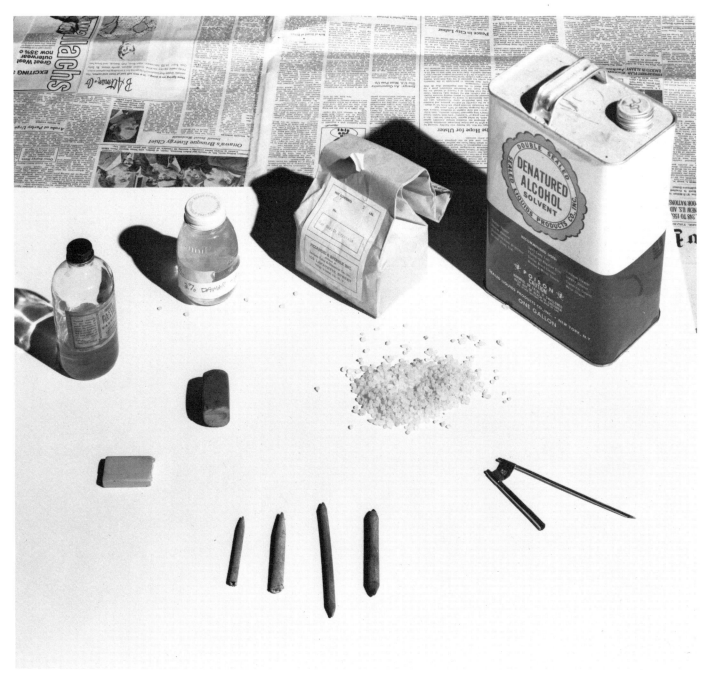

5. *Materials for making fixative: (from back to front) Weber pastel fixative, solution of 2% damar and 98% alcohol, gum mastic crystals, denatured alcohol, kneaded eraser, art gum, stumps, and mouth atomizer.*

Morning Times. *Pastel on paper, 21" × 29". The textured background was created with soft pastel on a tan-colored sheet; this necessitated much spraying and reworking to achieve the proper effect. Although the painting consisted largely of middle tones, the full range of values was employed, extending from the dark of the chair to the white of the newspaper. The light areas were painted with a thicker impasto and heavier pressure. (Collection Mr. and Mrs. Louis Levy)*

twisted to present a clean surface, which is essential in erasing pastel.)

Pass the edge of the blade no more than once or twice across the surface of the area to be erased, scraping the layer of pastel; this removes the excess pastel granules. Always scrape an area a bit larger than what you want to erase. Making sure that your eraser is perfectly clean, erase *only* that area you've scraped. If you try to erase an unscraped layer of pastel, it will smear.

After erasing, you may begin repainting. If you find the area you've erased isn't sympathetic to reworking, repeat the scraping and erasing procedure, spray some fixative lightly over the erased area, and then rework. A sandboard or marbledust board cannot be completely erased without the razor removing some of the granular surface. To repair it, sprinkle additional marbledust or sand on the bald spot and glue it on with a spray of fixative.

You can also use the razor blade to sharpen pencils and hard pastels (Figure 6) and to cut paper and backboards. When you're not using your eraser, store it away from your pastels to keep it clean.

Clips and Pins. Both spring or clamp-type clips — available in art supply, hardware, and stationery stores — are a good means of attaching your paper or painting board to the support board. Those with flat fold-back prongs are best since they slide in flush under the top bars of the easel; when you place the board on the floor they allow your board to stand without wobbling. Pushpins can also be used to attach the paper to a fairly soft support board like Homasote or Celotex.

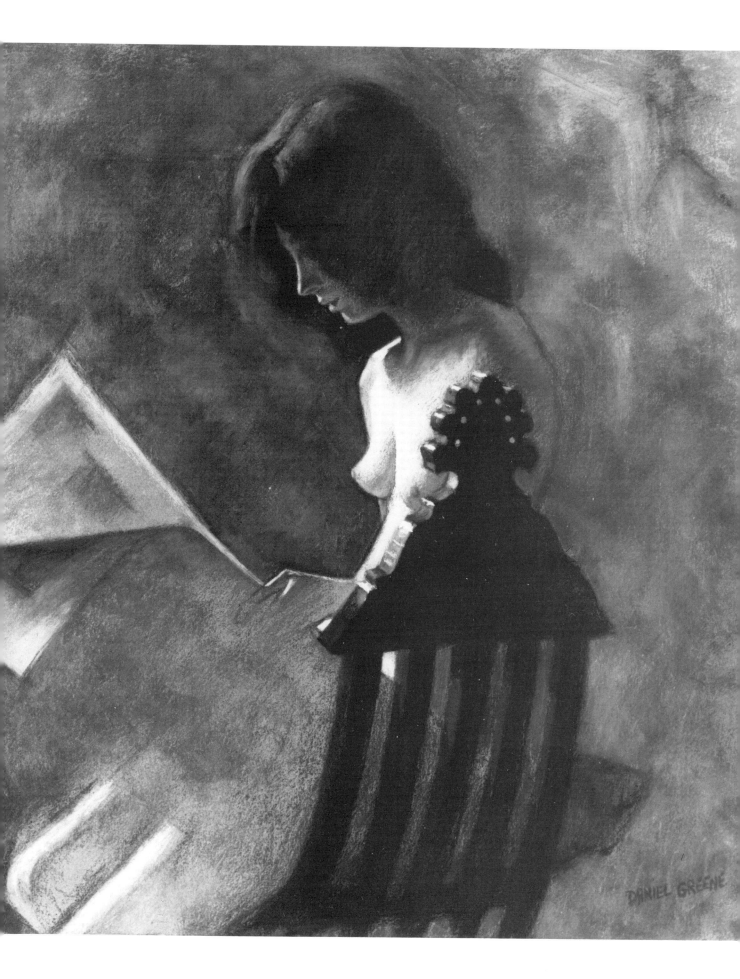

6. *To sharpen pastels hold the stick point firmly against a flat surface, and as you slowly turn the stick, sharpen it to a point, starting high and exerting gentle, downward pressure.*

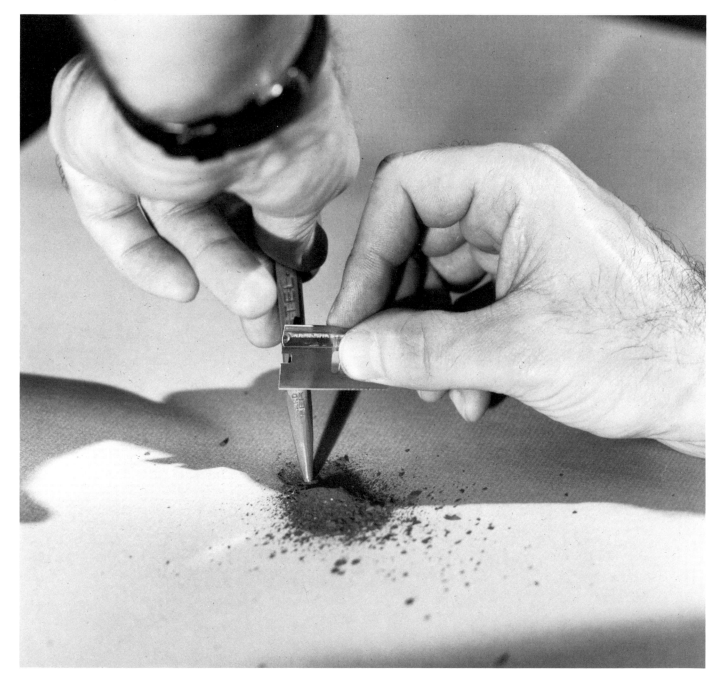

Tape. I put masking tape on the floor to mark the positions of my easel, model stand, and chair before the painting session is over, so these locations can be duplicated when I resume the same picture. Before transporting unframed pastel paintings, I sandwich pieces of cardboard between them, taping only the boards together so the tape never actually touches the paper. Don't use masking tape or any other kind of tape on the painting surface itself, since it pulls away the delicate surface and causes damage.

Rubber Bands. Since I tilt the top of the paper slightly forward when I'm painting in pastel, I find it useful to stretch a rubber band around the bottom of the sheet and drawing board to keep the sheet lying smooth and flat against the board. I use large commercial rubber bands; or if such big ones aren't readily available, I cut a number of ½" wide bands from an old inner tube.

Charcoal. Soft charcoal is very useful in pre-liminary drawings since it can be easily erased and doesn't leave a thick residue. Since charcoal is completely compatible with pastel, it can be used at any time in the course of the painting as a dark gray color or as a tone to darken other colors. I use sandpaper blocks to sharpen my charcoal sticks.

Mahlstick. This is a stick of wood or metal with a soft tip at one end. The tip is leaned on the painting or on the easel near the painting, and the other end is held in your free hand. The purpose of the mahlstick is to provide a steady brace for your painting hand without it touching the painting surface.

Stumps (Tortillons), Rags. Stumps, or tortillons, are narrow tubes of soft, rolled paper used by some pastel painters to fuse or blend tones. I seldom use them since I prefer to keep my pastel paintings relatively unblended. I do keep a supply of rags and paper towels on my taboret to wipe my hands or occasionally, a stick of pastel.

The Hippie. *Pastel on matboard, 40" × 32". I chose this pose to attain the appropriate lighting that would display the most interesting patterns of light and shadow, and the transition of color from shade to tint. The detailed designs in the poncho were first worked out in their largest, most simplified patterns, then gradually subdivided into ever smaller areas. (Collection Mr. and Mrs. Roger Heiskell)*

CHAPTER 5

SETTING UP
THE
STUDIO

The most important facet of painting indoors is the quality of the light that illuminates the subject.

Natural Light. The most desirable light is a north light because it remains constant throughout the day. East, south, or west light can be used in painting, but only for comparatively short periods, as the movement of the sun from east to west changes the appearance of the subject during the day.

A single light source (preferably from the north) is better than light from several sources, because you can more easily discern the subject's lights, shadows, and middle-tone areas. A secondary light source, for example a south light, would cast conflicting shadows in the opposite direction, enormously complicating the modeling of the form of your subject.

Another important factor in lighting is its direction. An overhead light or a light from a high window provides a natural, outdoors sort of lighting. A single light source above the subject doesn't cut across the subject and clearly illuminates the forms. Light coming from a low (perhaps 4' tall) side window will cast shadows on the side and across the subject. Light coming from below the subject creates unnatural, eerie highlights and shadows.

The color and intensity of your lighting can be changed or limited if your studio's windows are dirty or blocked by trees, buildings, window screens, smoke, strongly colored draperies, snow, or rain. The general brightness or dimness of the day will also alter the intensity of the light, but not its direction.

If the lighting in your studio is weak or obstructed, or if your studio is small, you should direct the light toward your subject rather than directing it at your easel. A well-lit subject and a weakly illuminated painting surface can result in a very strong painting when you finally view it in direct light. However, a dimly-lit subject and a brightly illuminated painting surface, will not necessarily produce a bright painting.

Artificial Lighting. If you must use artificial lighting, try a single light source angled from above, rather than from the side. Use a strong bulb — at least 200 watt — or a spotlight set in a tall stand. Both you and your model should receive illumination from this single light source, which should be placed to the left and behind you.

In addition to altering the color of objects, artificial light tends to cast rather sharp and harsh shadows. I find artificial light more appropriate for drawing or for quick studies than for more complex and protracted projects, which I prefer to execute in daylight. While a painting done in natural light will look fine under artificial light, the reverse is often not true.

When painting indoors at night, I sometimes attach a picture light to my drawing board to illuminate my painting surface.

To avoid artificial light shining into your

eyes, you can use an eyeshield or visor of the type worn by clerks at the turn of the century.

The Effect of the Walls on Studio Lighting. The tone and the color of your studio walls can have an enormous effect on the light illuminating the subject. White or very light walls may dilute the strength of the shadows by reflecting lights into them. Squinting while viewing the subject will help keep these reflected lights in proper value. Very dark or black walls cast deep, dark shadows and produce strong, dramatic lighting, however, color and detail are lost in the shadows. Middle-tone walls exert the least influence upon the light in the studio; consequently, you can choose whether to stress the lights or darks, transparency or opacity of a subject.

The color of the walls can likewise strongly influence the appearance of all things in the studio. For example, bright red walls would lend a reddish cast to all objects in the studio. A neutral gray would least affect the color of the other objects.

Another consideration is the *type* of paint used on the studio walls. A flat paint casts no reflections, a white shiny enamel often acts as a mirror and is therefore too reflective for a studio. Avoid reflective paint on your floor and ceiling also.

Positioning Your Easel. Since pastel is a matte or non-glare medium, you can station your easel at any angle without getting annoying reflections. My rule of thumb is to stand 10′ from the window with the light coming from my left (Figure 7). I place my easel at a distance of about three times the height of the painting away from the subject. (For example, if the painting is 30″ high, I would place my easel 90″ from the subject.)

As you move farther back from the subject, the values and overall proportions become more apparent, but the colors and details become less distinct. Therefore, it's often useful to begin a painting with your easel far away for an overall viewpoint, then move it in closer for final details.

A final consideration in positioning your easel is perspective. Looking at a subject from above or from below alters your view of it and of all objects included in the picture, such as chairs, baseboards, etc.

Sight Size Painting. Sight size painting is a method used by some artists to help visualize proper proportions in their paintings. The artist stands at a fixed distance from the subject (perhaps 12′), then places his easel between the subject and himself so the living subject and the painted subject appear exactly the same size. The artist views the subject from his fixed position, approaches the easel and makes the appropriate stroke, then backs up to his fixed position to repeat the procedure.

If the artist is painting the subject lifesize, he places the easel next to the subject while he remains in his fixed position, about 12′ away. If the subject is painted three-quarters lifesize, the easel is placed three-quarters of the distance between the artist and the subject.

This method can also be used to check the accuracy of proportions in the conventional method of painting. The artist paints at the normal viewing distance (three times the height of the painting) but he moves the easel up close to the subject to check the propor-

Still Life — Bread and Cheese. *Pastel on sandboard, 24" × 28". When I set up this still life I placed a piece of cardboard 24" × 20" on the left of the table to partially block the light from the window, casting some shadows across the arrangement. This created the interesting problems of painting half-lit objects next to those fully illuminated. The pastel was heavily applied throughout the painting with the darkest, lightest, and most thickly painted areas in front. (Collection Mr. Raymond Gruenwald)*

Corner of the Room. *Pastel on sandboard, 30" × 25". I first sketched loosely in pastel to establish the scale and composition of the various components. An important primary consideration was establishing the eye level in order to control the perspectives of the wall and picture frame. This was a south light situation and so the character of the shadows on the walls (which would change rapidly in this illumination) was quickly registered.*

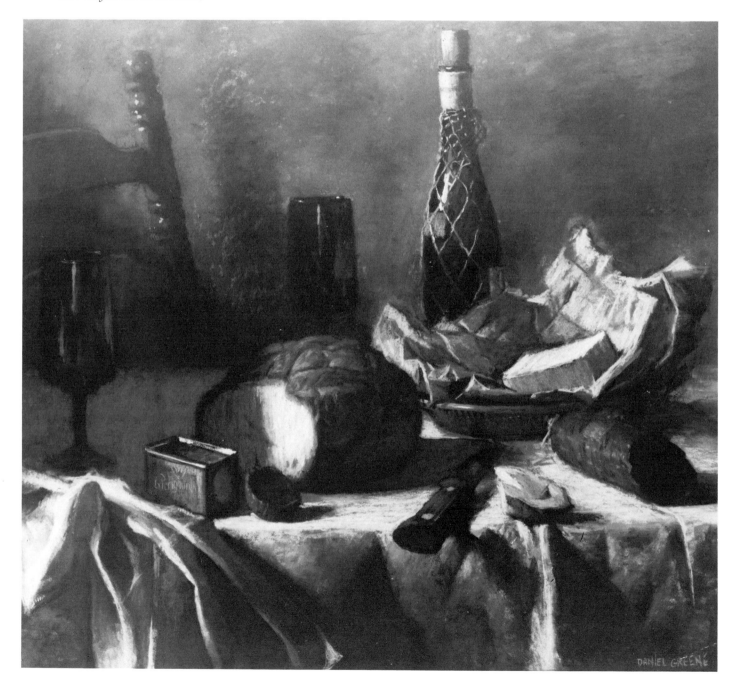

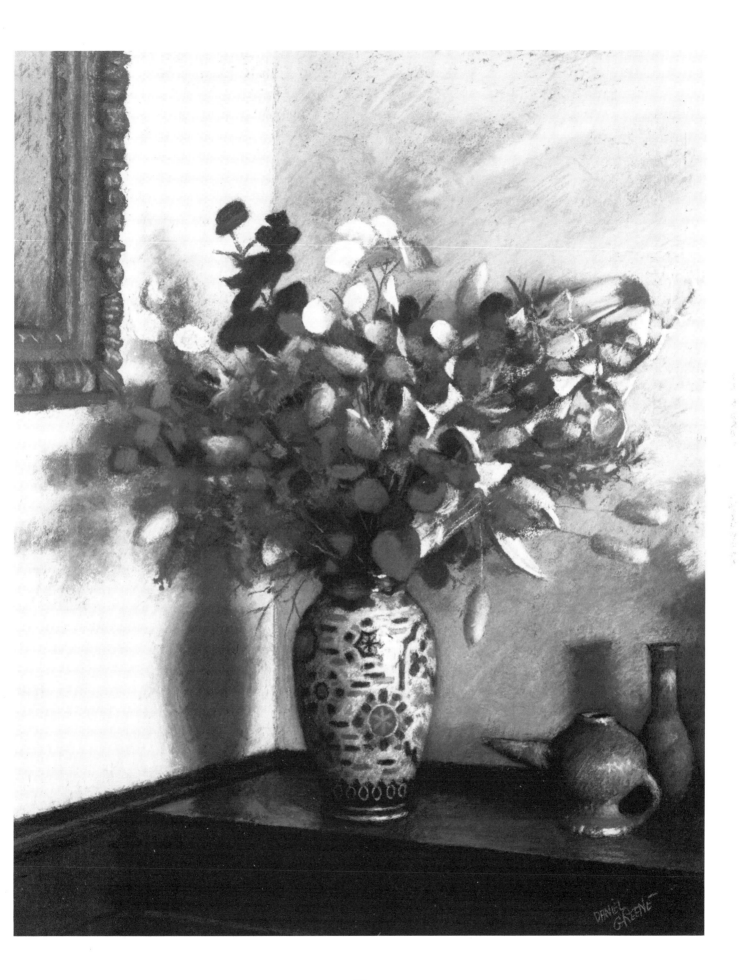

tions. Then he makes his corrections with his easel still close to the subject or moves it back to its normal position.

Stand or Sit. An artist's view of his subject naturally changes depending on whether he sits or stands during the painting session. There are things to be said for both positions. Sitting is more comfortable, but it makes it less convenient to get up and view the painting from a distance. Standing is more appropriate for large paintings because it allows the artist to view the entire painting surface at one time. Standing also makes it easier to reach out for the many pastels that must be handled. In portraiture, standing customarily permits an eye-level view because the standing artist parallels the height of the model sitting on a chair on the model stand. Sitting makes for a steadier painting hand, but standing permits more verve in the stroke of the arm. In pastel painting, standing avoids the inhalation of the pastel dust as it crumbles and falls off the surface, and likewise minimizes the inhalation of the fumes of fixative.

Generally speaking, I would advise standing for bigger, looser paintings, particularly those of live subjects, and sitting for smaller, detailed paintings where it's more desirable to be close to the subject. A good compromise is a high stool which puts you about halfway between the sitting and standing positions. In a situation where the source of light is a window close to the floor, it's better to sit and work without a model stand to keep the light as high as possible on the subject and the painting surface. Needless to say, once the painting is begun, the artist shouldn't switch positions, that is, viewpoints.

Placing the Taboret. The most convenient place for your taboret is between the easel and the light source so that you can easily see and reach for the proper stick when you need it.

Keeping the taboret close to the easel and in close proximity to the subject makes it easier to compare colors and values, and to make rapid pastel selections without turning back to the taboret and trying to remember the shade you want to reproduce.

To prevent casting your shadow over the colors when the light comes in over your left shoulder, keep your taboret on your left side. When the light comes in from your right, move the taboret to your right side.

Model Stand. A model stand is especially valuable to me since it puts the sitter on an eye-to-eye level with me when I work in a standing position. My model stand folds out like a dropleaf table and like just about everything else in my studio, it's mounted on casters for easy mobility. It's about 1' tall and is large enough to accommodate not only a chair, bench, or couch for the model, but some additional props as well. I usually put an old rug on the stand under the sitter's chair to keep it from sliding.

I keep a number of carefully chosen chairs, benches, tables, stools, and couches in or next door to my studio to be ready for any painting contingency. Some chairs have arms and some don't; some have solid backs while others are latticed, still others are plain wood or upholstered, stark in design or intricately carved. When planning each portrait or figure study, keep in mind that the chair will affect the way the model sits and poses. For a portrait including the hands, I usually select a chair with

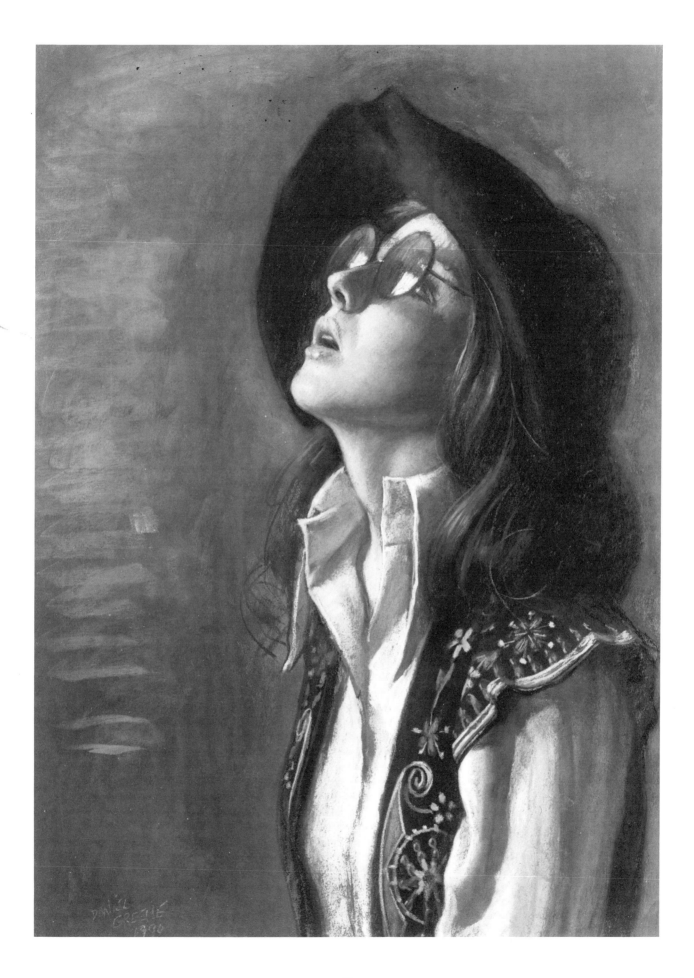

Pony and Steve. *Pastel on paper, 21" ×
29". The two models posed separately,
however I made sure that the light
illuminating them came from the same
direction. The contrast between the two
models was interesting in that Steve's
skin coloring was primarily cool, while
Pony's leaned toward warm brown tones.
(Collection Nancy Ellen Hurlimann)*

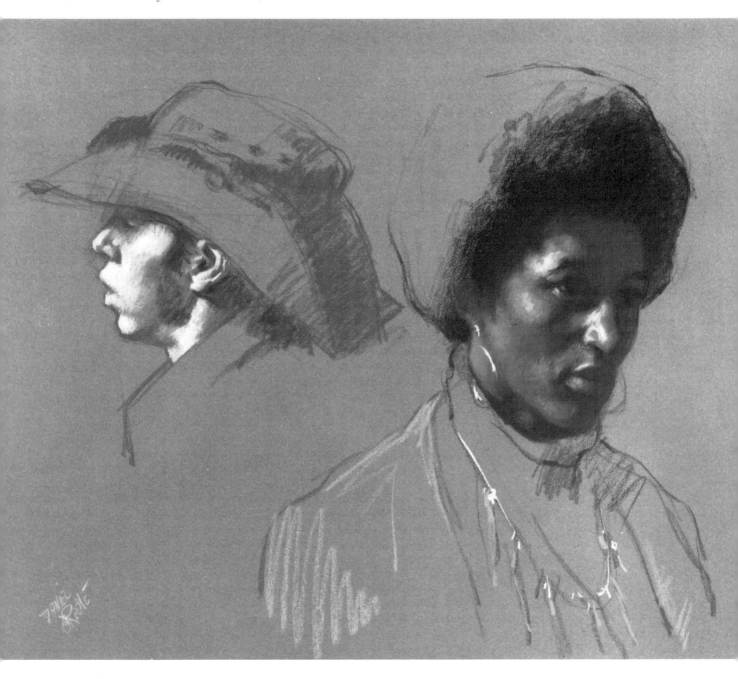

arms; for a back view or nude pose, I use a low-backed chair, stool, or bench. I also consider the color of the upholstery and wood in the general color scheme of the painting.

Between painting sessions, the model stand can be used as a general work area, for cutting paper, etc.

Backgrounds. Before beginning any painting, study your subject and select a color for the background that contrasts with or complements the subject. (It's a good idea to paint your studio walls a neutral color like medium gray as a basis from which you can go lighter, darker, duller, or brighter in your choice of backgrounds.) Using screens and draperies, create the background value that you have chosen. An even-toned background is best, so the values of the subject can be easily and accurately compared and related to the background value while painting. Accumulate the widest possible selection of drapery materials in various colors, shades, and textures — with emphasis on dull rather than shiny fabrics, which tend to draw attention away from the subject and often reflect unwanted lights.

You can either tack your draperies to the wall or drape them over a screen behind the subject. (I use a three-way folding screen that's tall enough to block the wall if necessary.) Draperies can also be used to cut down unwanted reflected lights which minimize the desirable effect of a primary light source. Unless you wish to include the drapery as an integral part of the picture, not merely as a background, drape it so that no distracting folds or wrinkles are apparent.

Naturally, such items as framed pictures, tables, sofas, curtains, windows, etc. can be incorporated into the background.

Mirror. A mirror is one of the most valuable studio aids in all painting, particularly in portrait work. Place a fairly large mirror (over 25″ × 30″) on an easel mounted on casters so it can be moved about and station the mirror about 8′ away, facing your painting easel. This reflected, reversed image offers you a fresh glimpse of the painting and renders any mistakes that much more apparent. In addition, the image in the mirror is double the distance from the easel to the mirror, and allows the artist to see the painting from a distance without moving his position. You can check values, colors, contrasts, color harmonies, large patterns, and the accuracy of your drawing much easier when viewing the painting in the mirror. The mirror is particularly useful when it's angled to show both the subject and the painting at the same time.

In portrait work, I usually arrange the mirror so that the subject can watch himself being painted. This usually interests and involves the sitter in the progress of the painting, and eliminates the shock of viewing the completed portrait for the first time. If I sense apprehension on the part of the sitter, or indications that he will not understand that each stage of the painting is merely a part of its overall development and not a final version, I simply turn the mirror away.

DEMONSTRATIONS

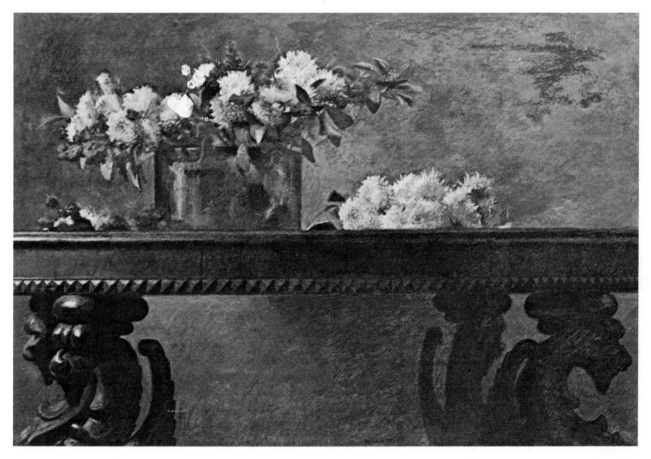

Gargoyle Table. *Illustration board (100% rag) toned with green acrylic paint mixed with marbledust, 30" × 40". I drew the main elements of the composition in hard brown pastels and soft charcoal. Using acrylic paint, I quickly placed some of the lights and darks in the drawing, then painted the flowers, copper pot, gargoyles and wallpaper. Then, with pastel, I developed the darks of the table, pot, and leaves, redrew and highlighted the gargoyles, and registered the strong, warm color accents in the pot. I used only strong, rich, very soft pastels to strike the lights of the flowers.*

Winnie

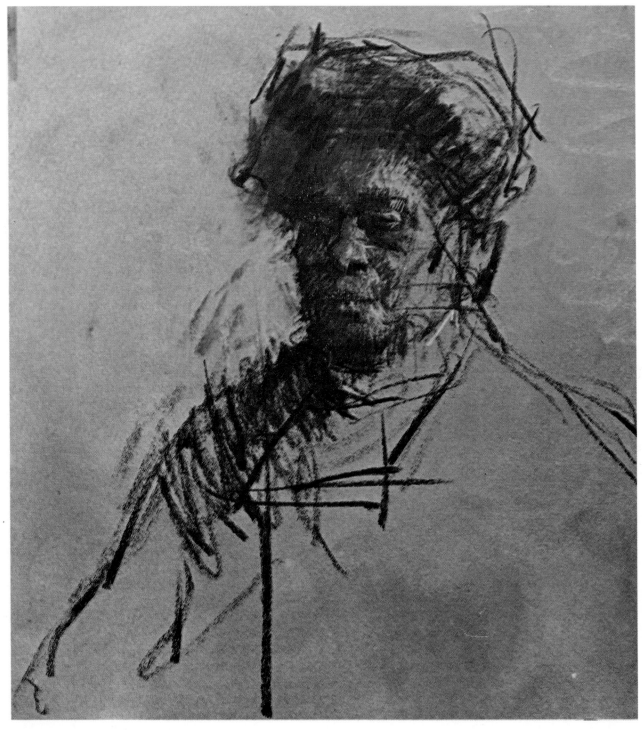

Step 1. *(Fiber-finish pastel board toned with gray casein, 26" × 30".) With soft charcoal, I sketch a rapid impression of the head and shoulders to establish the major elements. I quickly indicate the proportions of the forehead, nose, chin, and hair. I drop a number of vertical lines to relate the mouth and chin in size to the nose and eye socket. Then I run a horizontal line along the side of the head from the mouth and nose to establish the bottom of the ear. I stroke some burnt sienna into the forehead, nose, and lips to define the divisions between the lights and darks. I indicate the collar line with a nearly pure white stroke.*

I lay in some darks, beginning with the deepest darks in the hair and eyes and developing large masses with soft charcoal. Employing warm browns and cool dark grays, I work out tone and color in the shadowed areas of the face. I keep my strokes deliberately light and broken. Now working from left to right, I lay in the cool grays and warm rusts. Next I sparingly place a few cool lights at the corner of the mouth, along the cheek, and the bridge of the nose. I use a soft blue-gray in the background.

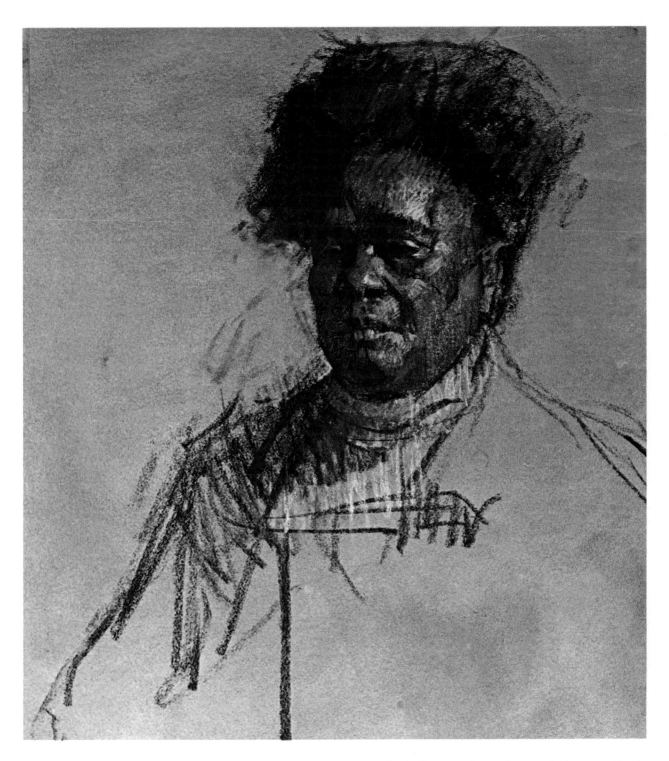

Step 2. *Again working from dark to light, I re-establish all the darks in the portrait, paying particular attention to the exact value and shape of the shadows, and to the placement of cool and warm colors within the dark areas. I do this also in the middle-tone areas, still keeping in mind the shadow patterns in the center of the face. I place stronger highlights on the nose, forehead, and in the eye socket.*

I begin to develop and refine the colors in the face, using warm yellow-rusts and cool purplish reds, blue-grays, violets, and red-grays. (Note that I avoid using browns, sticking mainly to warm and cool reds, grays, and violets.) I place a deliberately bright orange in the ear, forehead, and nose to initiate a richer, brighter range of colors. It's better to step up colors than to tone them down.

A few yellow-white vertical strokes in the sweater will remind me to relate the intensity of the light on the forehead and nose to the white of the sweater at a later stage.

Winnie

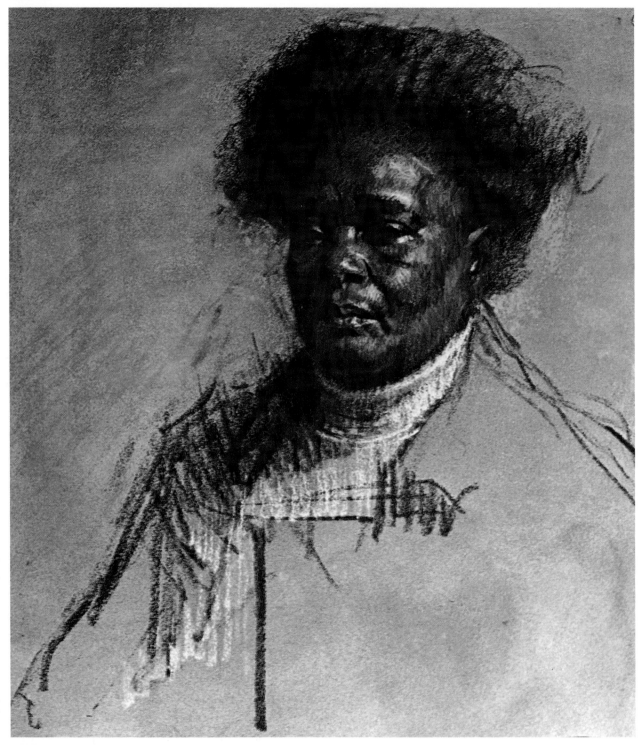

Step 3. *Now I redraw, strengthen, and simplify the model's cheek and skull with a red-brown pastel. I model and soften all the various forms throughout the portrait. I simplify the highlights to help determine their final shape and value, placing lighter highlights in the nose, eye socket, and corner of the mouth. I lighten the right eye to judge how brightly to paint the left eyelid by contrast. I paint the muscles of the forehead above the eye in more detail, and work on the outside contour of the hair. With a dull, yellowish tone, I bring the sweater down in size, and then develop the patterns in the sweater and the shape of the turtleneck, progressing from dark to middle tone to light.*

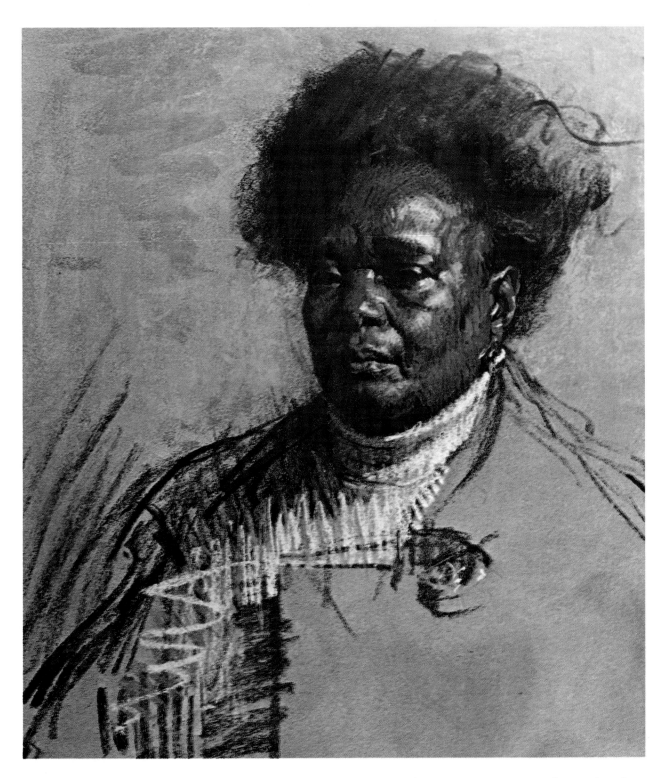

Step 4. *I paint the ear in darks, middle tones, and lights, using yellow accents to suggest the earring. I redraw the shoulders on both sides of the model, emphasizing the figure's overall width. I stroke in the shadow of the sweater next to the coat lapel with black, and then paint rapid, rough black strokes behind the model's right shoulder to suggest cast shadows in the background. As a final touch, I sharpen all the details, refine all the soft and hard edges, and accent such forms as the hair, head, and sweater.*

Step 1. *(100% rag illustration board with a smooth white surface, 24" × 36".) Using Nupastel No. 283 Van Dyke brown and No. 223 burnt umber, I lightly sketch in the basic compositional elements. I place the tabletop in the very center of the painting — which deliberately defies the convention that a picture plane should never be divided into halves — but the busy, detailed tablecloth will direct the viewer's eye away from this stark horizontal. I establish the centerfold of the tablecloth, the middle of the basket, and the basket handle somewhat off-center to avoid breaking the painting up into precise quarters. Likewise, I divide the tablecloth into three unequal horizontal sections, then indicate the large circular patterns in the tablecloth. At this stage, I mentally note the placement of the lights, shadows, and colors in the total picture.*

Step 2. *I choose a cool green tone for the board, as a contrast to the warm orange of the apricots. After fixing the drawing, I mix a green acrylic wash and brush it lightly over the board so the drawing notes still show through underneath. While the tone is still wet, I repeatedly sprinkle the board with some marbledust and spray it again with fixative, until I achieve the rough texture I want.*

Step 3. *With soft pastel, I place some dark accents in the tablecloth, apricots, grapes, and dish, rendering these dark areas bigger than they really are, since later I will cover these with lighter values. I also indicate the light areas, applying very light pressure to achieve an open, broken-stroke area that can be subsequently closed up, tightened, and lightened.*

Now, with a middle-tone gray applied lightly, I indicate the vertical lines representing the various folds within the tablecloth. Notice the irregular occurrence of these folds; this prevents a monotonous, picket-fence appearance.

I paint the grapes on the right of the table in broad middle-tone masses with a few lights. I use a deep blue to add emphasis to the dish holding the apricots.

Step 4. *I develop the complex patterns of the tablecloth with soft charcoal and add shadows in the cloth with a dark gray pastel. I refine and correct the open parts of the lace represented by the dark horizontal bands. I darken the background around the basket and the tabletop, leaving much of the painted tone visible to retain its interesting textural effects. I test combinations of warm and cool colors in the shadow area of the basket, and use additional warm and cool colors for the apricots in the dish and basket.*

To seal the pastel and to deliberately darken some of the lights on the tablecloth so additional light values can be added later, I spray the painting with fixative.

Step 5. *Now I work on all the light areas, using a soft white pastel on the tablecloth to establish the highest values in the painting and to provide a standard against which to measure all the other lights in the picture. I brighten the lights on the dish and define some of the individual grapes that are in front of the basket.*

Using the soft charcoal, I further subdivide the intricate patterns within the tablecloth, then redraw and repaint with pastel to achieve greater accuracy of form and color. I do the same with the apricots in the dish and basket, and to the blue paper within the basket.

I spray the painting again in preparation for additional repainting.

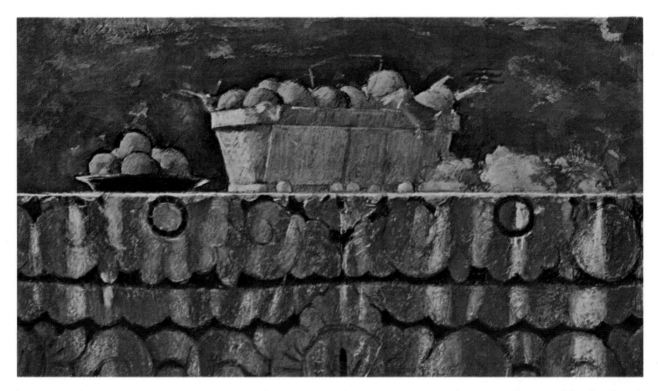

Step 6. *I soften and sharpen all the edges in the painting. Then I further refine the various loops and intricacies of the lace patterns within the tablecloth and define the folds of the cloth with some deeper, darker grays. Studying the tablecloth, I decide to rework some of the lighted folds of the cloth to avoid a too-vertical feeling.*

An interesting visual effect appears — the two strips of light showing through the open parts of the lace at the extreme left of the picture — and I decide to incorporate it. (It's never too late to take advantage of some new factor that will benefit the ultimate picture.)

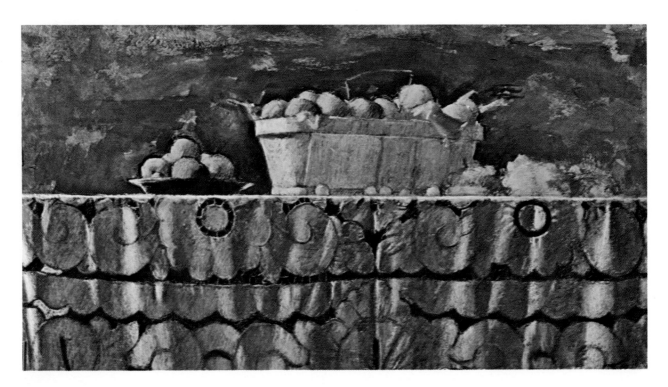

Step 7. *With a hard black pastel, I further deepen the dark areas that represent openings in the lace. This makes the light areas of the cloth appear still lighter by contrast. Redrawing these patterns also lends a crisper, sharper quality to the total design of the lace. Still working from dark to light, I completely remodel some of the shapes and forms of the cloth, adding several lights to attain additional crispness. Now I introduce gray lines representing strands of lace in the area left of center. I redraw and remodel the folds of the cloth in the extreme right of the painting.*

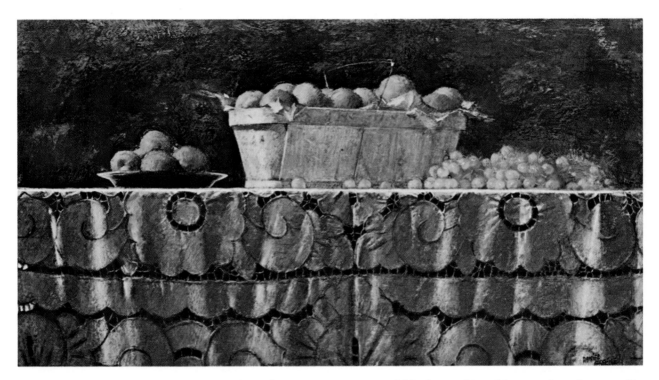

Step 8. *I strengthen the lace details, applying heavy pressure on a soft black pastel to achieve a crisp, sharp quality in the tablecloth. I use dark gray pastel to indicate the back-lit strands of lace in the extreme left of the painting. I finish the cloth by spraying and accenting it with the highest possible highlights.*

Now I pick individual grapes out of the masses with warm and cool greens. Some of the grapes tend toward blue-green or turquoise, and others toward a yellow-green. I redraw at the correct angle and accent the handle of the basket, sharpen and accent the seams of the basket, and add detail to the texture of the wooden sides. I change the shape and direction of the blue paper in the basket on the right, angling the paper so it forms an imaginary line extending from the edge of the grapes to the highlight on the handle.

Finally, I spray the picture lightly to adhere the loose pastel to the surface, but not heavily enough to darken the values.

Chen Chi

 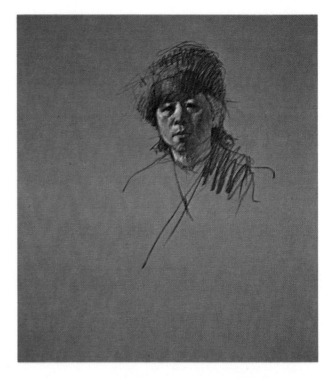

Step 1. *(Canson pastel paper premounted to a rigid backboard, 46" × 40".) The idea for this portrait resulted from a chance meeting with the eminent watercolorist Chen Chi while he was painting one of his landscapes. I was struck by the fur hat and the fur-collared coat Chi was wearing and decided to include these items in the portrait, along with a suggestion of one of his distinctive watercolors in the background. This presented the challenge of simulating the varied textural effects of Chi's watercolor painting in the medium of pastel.*

First I use sharpened Nupastel No. 283 Van Dyke brown and No. 223 burnt umber to indicate the placement and size of Chi's head, and to work out the proportions and placement of the individual features and hat. Then I place some warm and cool colors in the middle-tone areas and begin massing the shadow areas of the head and hat.

Step 2. *Now I apply warm and cool colors in rough, broken strokes with light pressure throughout the face, making a mental note to retain the color of the paper in some selected areas later in the painting. I continue to develop dark, middle-tone, and light areas, relating the shadow values in the head to the darker shadows in the hat and shoulder as seen against the background.*

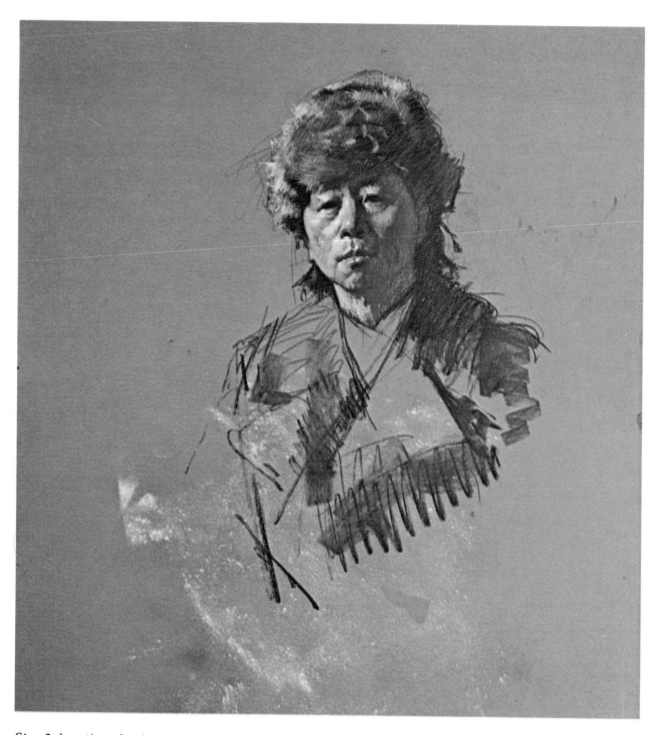

Step 3. *I continue developing the values and colors in the hat and head. I establish distinct side and frontal planes of the hat by controlling the values and reducing them to obvious darks, middle tones, and lights. I indicate large masses of shadow in the coat and collar, using the broad side of a soft gray-blue pastel, and alternately drawing and painting. Then I remove the painting from the easel, lay it flat, sprinkle marbledust on the coat area, and spray it with fixative.*

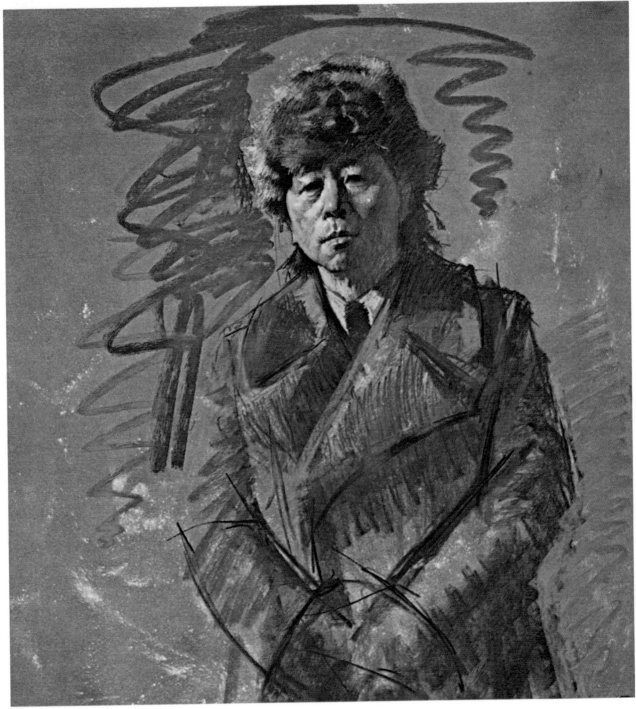

Step 4. *I develop the cool areas of fur, and the warm areas of suede throughout the coat, and register a few pink lights in the collar. I try several rapid, test strokes in the background.*

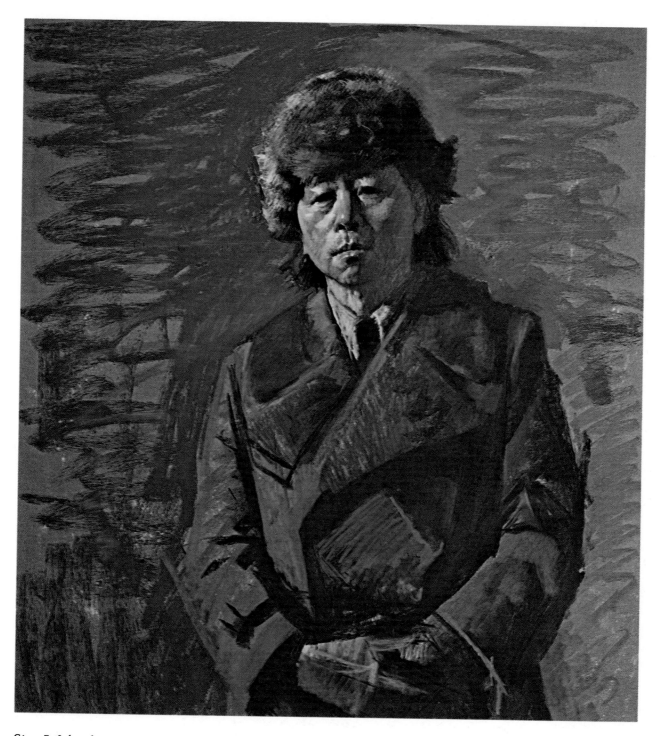

Step 5. *I develop masses of shadows and lights all over the coat to gain proper proportion. I sketch in the hand and book. (Accuracy of color and modeling details should be deferred until all proportions are correctly established.)*

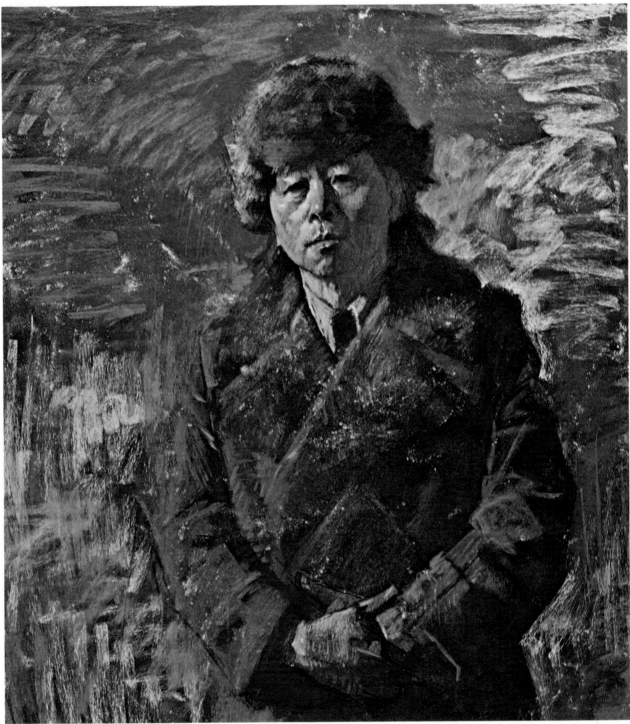

Step 6. *I mask out the face and hat, sprinkle marbledust all over the painting, and fix it, deliberately roughening the surface in certain areas. I begin the background with broad, light strokes of the colors in Chi's painting, positioning the color areas and patterns according to the painting, but deliberately enlarging their size.*

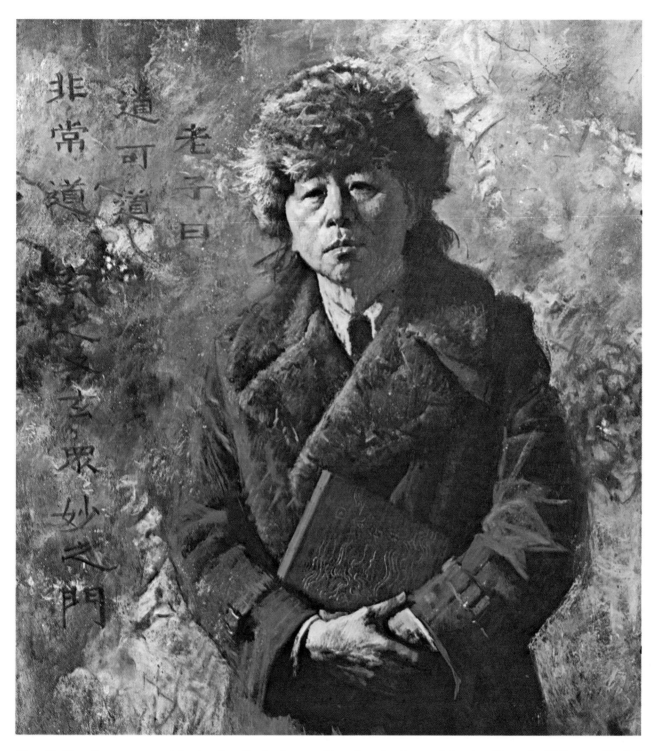

Step 7. Here I more accurately develop the background by choosing large abstract patterns in Chi's complicated painting and repeatedly subdividing them into appropriately smaller shapes and patterns. To duplicate Chi's great variety of textural effects, I use the side and tip of a soft pastel only, varying the pressure as necessary. I also shave off pastel granules and add them to several areas in the background to achieve a distinctive texture.

I complete the hands. I check and correct the accuracy of the drawing, values, color, and edges throughout the painting. Finally, I introduce the Chinese characters into the background, then lightly spray the picture with fixative.

Standing Nude

Step 1. *(Fiber-finish pastel board, 30″ × 20″.) Using soft charcoal, I roughly sketch in the figure to establish its scale and placement. With gold and brown soft pastels, I indicate the lights and shadows throughout the figure. Then, with soft charcoal again, I work out the proportions of the larger parts of the body. I select a spot on the right hip from which I cast a plumb line up and down the figure. This plumb line, and lines drawn parallel to it, indicate the edge of the shadow on the waist, the right knee, the right ankle, the back of the head, and the right armpit.*

After aligning all these points, I make note of the angles in the figure: the angle of the right knee to the foot, the right knee to the right hip, the right breast to the chin, the right shoulder to the elbow, the right breast to the groin.

Next I locate important horizontals: the breasts, the elbow, the right knee, the left foot, the shoulders, the space between the shoulder and chin, and the top of the head.

To double-check my proportions, I hold a pencil vertically and squint at the model, noting the placement of the head in relation to the inside of the thighs. Then I hold the pencil vertically against the painting, noting where the inside of the thighs begins in relation to the head.

Step 2. Now I begin to paint the figure, proceeding from dark to middle tone to light, finding and placing the appropriate warm and cool colors, and working in large masses, using light pressure and broken strokes. (I keep my light areas somewhat subdued, anticipating a further lightening of these values in the subsequent stages. Compare the hair in this stage to the hair in the final painting.)

I deepen the background and vaguely indicate the drapery hung over an easel behind the model. I redraw the model's left foot, and then contour it and the rest of the figure using the colors of the background.

I spray the painting heavily to adhere the pastel to the surface and to deepen the values in the hair and in the shadows on the body. I emphasize and enlarge the section of hair seen through the crook of the elbow since it provides an interesting back-lit accent that helps define the shadows on the arm and waist. I also draw a strand of the model's hair as it falls over her right shoulder. Additional lights on the head help shape and model the planes of the hair as it falls gently in, out, and under, revealing graduations of dark to middle to light tones — all within the general light area of the overall value range of the painting.

Standing Nude

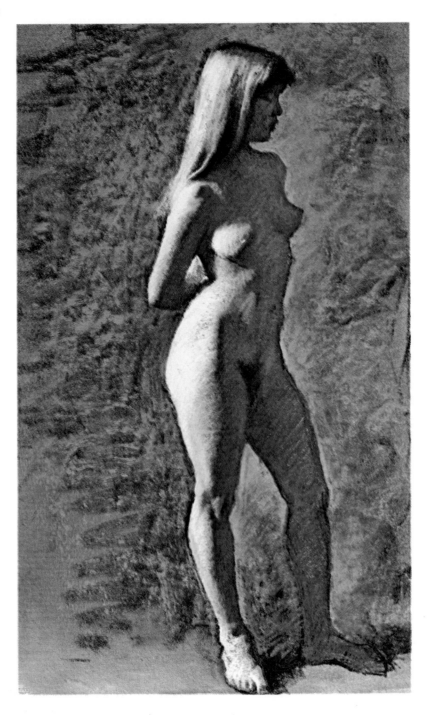

Step 3. *I restate the warm and cool colors more emphatically throughout the figure, with particular emphasis on warm strokes in the closer areas, and cool strokes in the receding areas. In general, I heighten and brighten the range of color throughout the painting.*

Notice that the reflected lights within the shadows on the body are never as light as the middle tones. By squinting, I can determine whether these strokes are in their proper value range or if they pop out excessively. I deepen the shadows in the hair considerably and eliminate the strand of hair on the shoulder to simplify the mass of shadow in that area. I sharpen and delineate the overall shadow patterns on the body, particularly where they meet the light areas.

I decide to treat the background as tone, rather than rendering the studio interior, and so I cover and lighten the background with cool violets.

I further mass and simplify the model's left leg. I give the right leg and foot some cool touches, then develop their form and shadows. I indicate the toes and add warm ochres to the thigh and shin. I paint additional details in the breast and face.

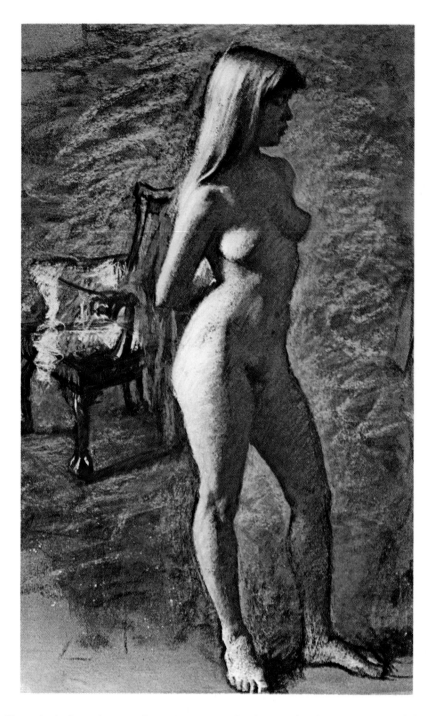

Step 4. *Now I decide to include a chair in the painting. To do this, I take the picture out of the easel, sprinkle the marbledust thickly where the chair will go, and spray it heavily with fixative. I draw in the chair roughly with charcoal, making sure to relate it accurately in size to the model and to construct its boxlike shape in proper perspective. I indicate very sketchily all the lights falling on the chair and cloth. Darkening the background with fixative makes further painting of that area less imperative.*

 I intensify the ochre lights on the left leg and foot.

Standing Nude

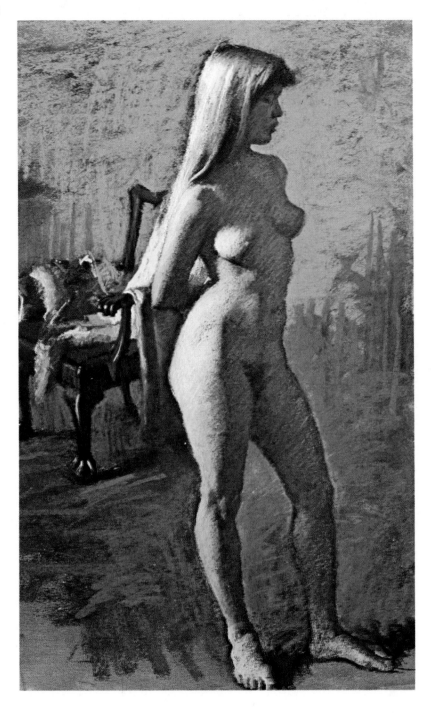

Step 5. *I spray the painting with fixative to further darken the colors and values in the background, and sprinkle on marbledust to provide additional tooth in the area occupied by the chair. I repaint the background, giving a more interesting shape to the vignette, and changing the colors from mauve to gray on top and gold on bottom, as a contrast to the warm accents on the cloth. A few crisp strokes running in various directions in the background provide additional action. I lighten and simplify the chair and the blue cloth, adding crisp, pure color accents to the multicolored cloth. I place highlights in the legs and arms of the chair to strengthen its form. As a final touch, I lay strong, light values on the hair, arm, hip, and breast, and then fix the completed painting.*

TECHNIQUES

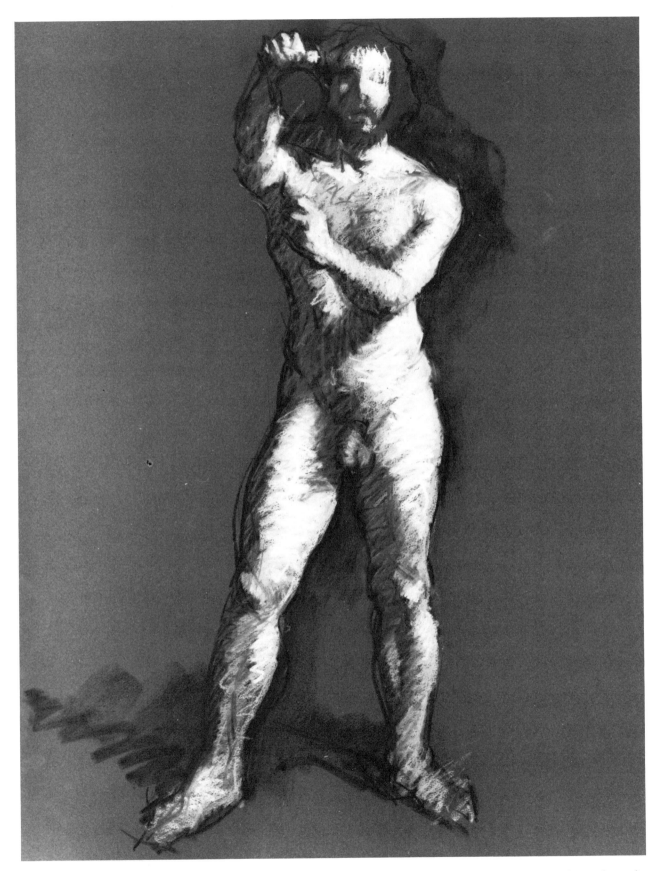

Diogenes. *Pastel on paper, 24" × 20". In this rapid study the character of the pastel strokes is prominent throughout the figure. No effort was made to blend or disguise the loose, rough, early stages of preparation. Once my intentions were realized, I put the study aside.*

CHAPTER 6

HOW TO APPLY PASTEL

Strokes applied with the side of a soft pastel will build up layers. The thickness of these layers depends on the amount of pressure applied, the texture of the surface, and the relative softness of the stick used. Generally, light pressure is needed to control the amount of pastel deposited, particularly on paper surfaces. Heavy pressure will produce a thick, smooth, easily smeared and blended layer of pastel.

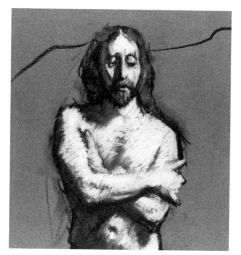

On granular surfaces, side strokes with a soft pastel can be applied with light pressure many times before the grainy surface is completely covered. On a very rough marbledust board it takes greater effort to fill the rough, irregular texture, and repeated strokes of heavy pressure are required to produce the semblance of an even tone. (See Figure 8.)

Side strokes made with a broken piece of a hard pastel about 1" to 1½" long, are more practically applied to smoother surfaces such as charcoal paper or Canson pastel paper. Such strokes impart a rather even tone with minimal graininess. Sharp, crisp, rectangular strokes are obtainable with medium to heavy pressure. Large areas aren't as easily covered with the side of a hard pastel as with the soft. A slight wearing down of the square edge of a hard pastel on practice paper renders it somewhat easier to spread on a surface.

The side of a hard pastel on a granular ground encounters great resistance and tends to wear away the surface tooth. I find little use for the side of a hard pastel on rough or granular surfaces, preferring soft pastels for this purpose because they flow on more easily and produce the same irregular textures. (See Figure 9.)

Linear Strokes. The character of a linear stroke registers easily on smooth paper when applied with the blunt edge between the tip and side of a soft pastel stick. Sharp edges result from strokes applied to a close-toothed surface with medium or hard pressure. The rougher the texture of the paper, the more splattered and irregular the strokes obtainable. On sandboard, the clearly defined spacing between the strokes is harder to retain and the crisp-edge effect is softened. On rough marbledust board, only extremely hard pressure will produce a line, and any lessening of pressure during a stroke will result in a crumbly texture. The sharp edges of the top or bottom of a new soft pastel stick are best for producing sharp lines, rather than a blunted or sharpened tip. (See Figure 10.)

Some sticks of hard pastel can be sharpened to a good point, providing the consistency of their pigment and binder is hard enough. Such prepared sticks can produce the finest lines, more so on smooth rather than on rough surfaces. Other hard pastel sticks are softer and can only be sharpened to a blunt point, resulting in a slightly grainier deposit. With heavy enough pressure, the unsharpened, square edge of the hard pastel stick will produce a

	Charcoal Paper Smooth	Pastel Paper Medium

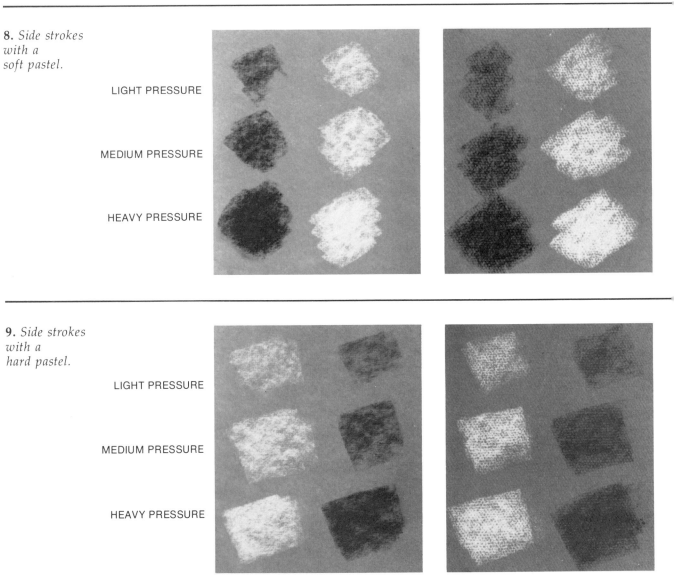

8. *Side strokes with a soft pastel.*

LIGHT PRESSURE

MEDIUM PRESSURE

HEAVY PRESSURE

9. *Side strokes with a hard pastel.*

LIGHT PRESSURE

MEDIUM PRESSURE

HEAVY PRESSURE

Sandboard Medium	Fiberboard Medium	Marbledust Board Very Rough

fine line, but such pressure will soon wear down this edge so that the stick must be turned to find a new edge.

Many hard pastels won't register at first on the repellent rough, granular surfaces, but they can be employed later over the softer layers of pastel. Testing hard pastels on various surfaces can help determine which and how they will accept linear strokes. (See Figure 11.)

Crosshatching. Crosshatching is an ancient artistic technique of creating tones through the use of overlapping horizontal and vertical lines. By increasing or decreasing the multiplicity of the strokes and by controlling the width of the spacing between them, tonal masses can be built up and developed.

A hard pastel sharpened to a blunt point is a natural tool for this technique. Initial crosshatching with hard pastel on a very rough, granular surface might be difficult due to the tendency of such surfaces to repel hard pastel. However, on top of pastel layers, crosshatching with hard pastel presents no problems. (See Figure 12.)

Crosshatching with soft pastel adds a somewhat grainy, splattered character to the strokes, making them less individually apparent. If a more linear quality is desired, harder pressure and wider spacing between lines are necessary. The sharp edge of the top or bottom of a new soft pastel stick will often provide this crisp, linear quality. (See Figure 13.)

Using the Tip. The tip of a soft or hard pastel can produce a variety of narrow grainy strokes or sharp lines. Such a tip may be worn down, sharpened to a point, or flat with sharp round or sharp square edges, as in a new soft or hard stick. The quality of the lines and strokes produced by these various tips depends largely on the amount of pressure exerted, the angle at which they're held to the surface, and the surface to which they're being applied. Heavy pressure results in crisp strokes that are particularly useful for highlight accents. A smooth surface results in sharp edges, and a rough surface in grainy, splattered lines.

For the finest stroke possible, use the sharpest tip of a hard pastel applied to the smoothest surface. Soft pastels add a degree of impasto to strokes made with their tips. For truly sharp-edged accents, it's often practical to break a stick and thus produce a new edge for its tip. (See Figure 14.) Light pressure imparts strokes that most clearly show the character of the surface texture.

Scumbling. "Scumbling" means applying light tones over dark in an irregular fashion so the underlying surface isn't completely covered up. This is done by skimming a pastel stick either over a darker tone of paper or over a darker layer of pastel.

On relatively smooth surfaces, only a minimum of scumbling is possible before the surface becomes too even and closed up. On rougher surfaces, more scumbling is possible due to the greater irregularity of tooth.

Soft pastel is much more preferable for scumbling because hard pastel will file down the surface tooth instead of depositing pigment easily. Working from dark to light and from hard to soft facilitates additional scumbling with softer, lighter colors. To permit continuous scumbling, spray an area with fixative, thus both darkening and isolating it for lighter layers.

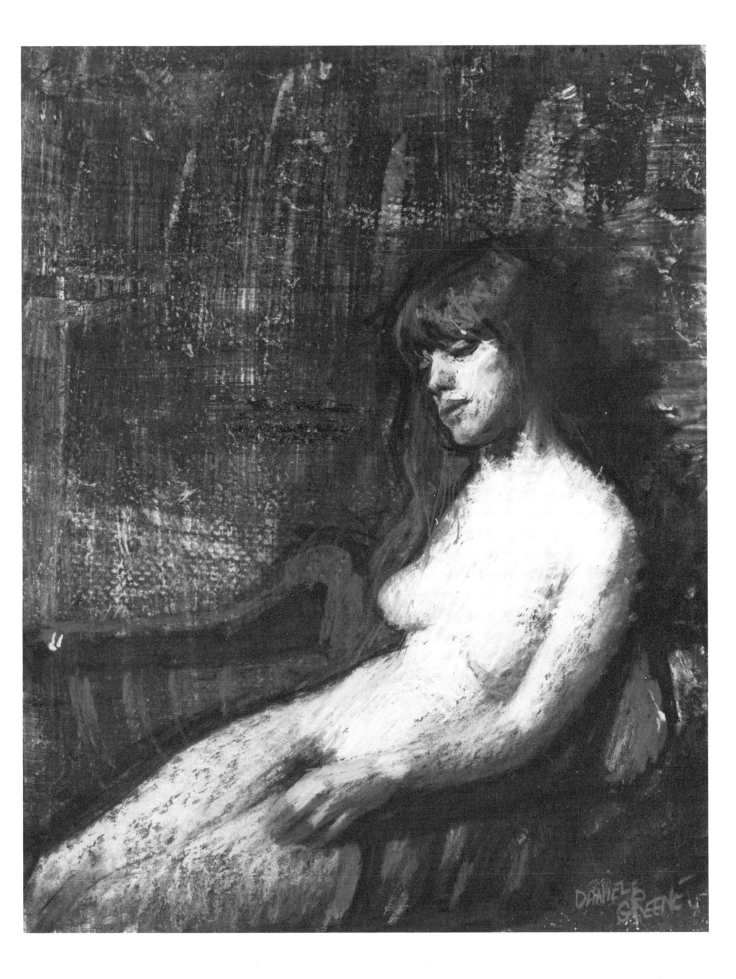

	Charcoal Paper Smooth	Pastel Paper Medium

10. *Linear strokes with a soft pastel.*

LIGHT PRESSURE

MEDIUM PRESSURE

HEAVY PRESSURE

11. *Linear strokes with a hard pastel.*

LIGHT PRESSURE

MEDIUM PRESSURE

HEAVY PRESSURE

Sandboard Medium	Fiberboard Medium	Marbledust Board Very Rough

	Charcoal Paper **Smooth**	**Pastel Paper** **Medium**

12. *Crosshatching*
with a
hard pastel.

13. *Crosshatching*
with a
soft pastel.

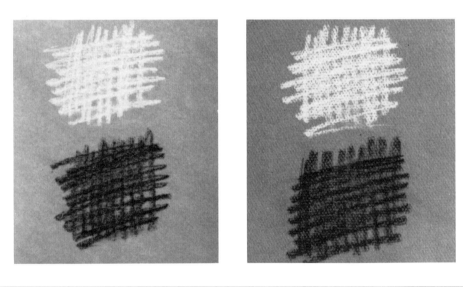

14. *Using*
the tip.

SOFT PASTEL

HARD PASTEL

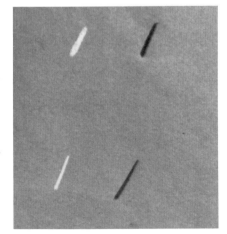
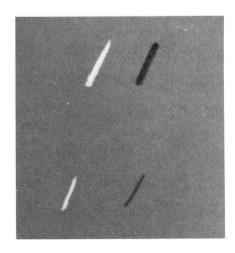

Sandboard Medium	Fiberboard Medium	Marbledust Board Very Rough

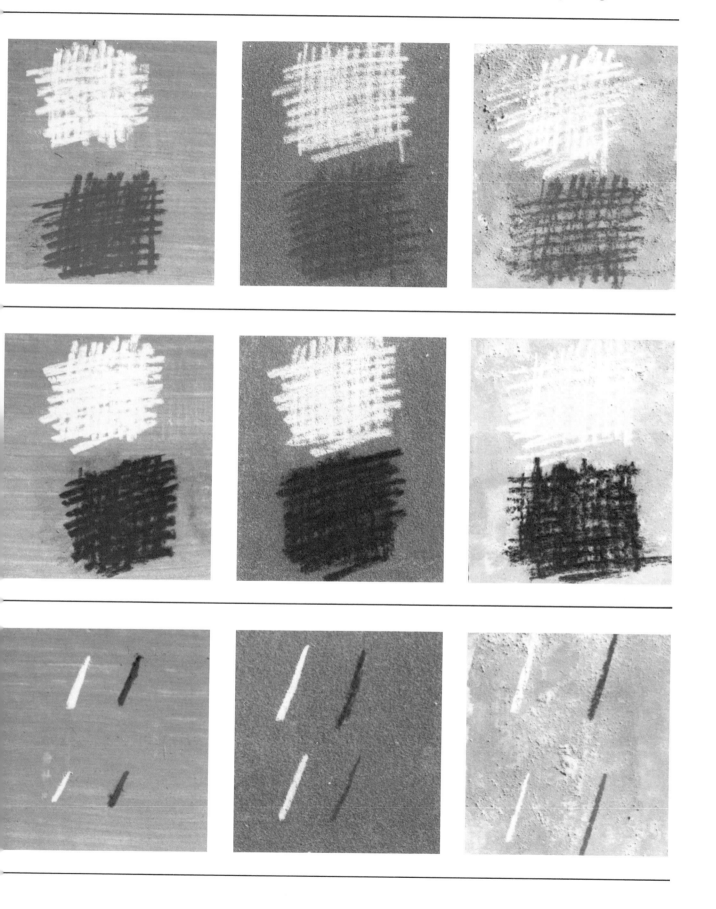

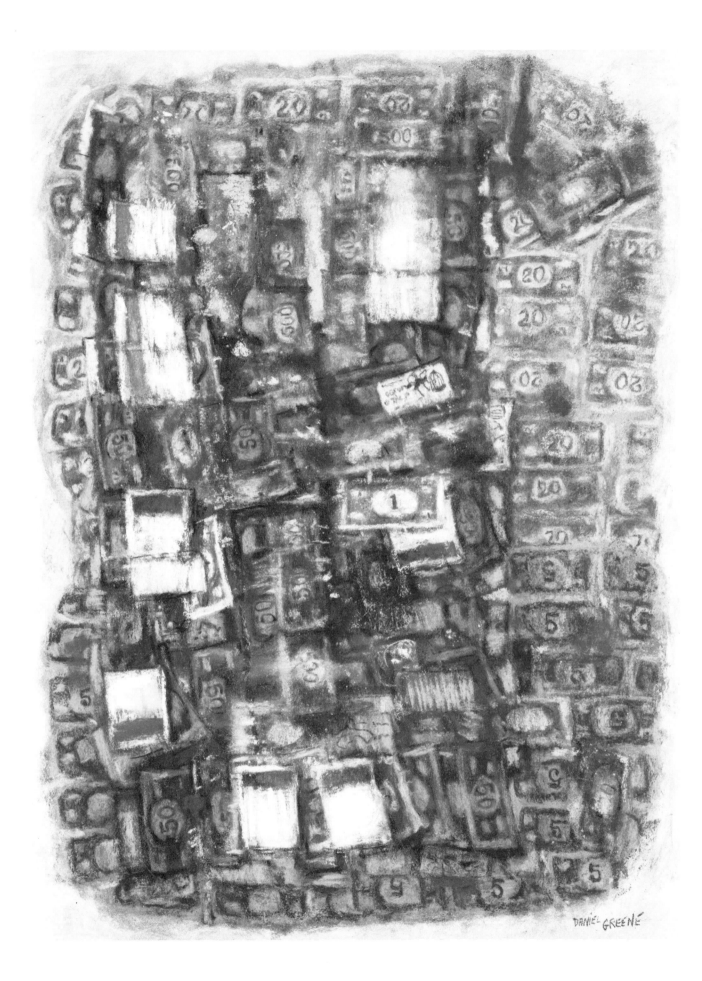

Get out of Jail Free. *Pastel on fiberboard, 30" × 40". To produce varying surface textures, the pastel was applied with different degrees of pressure and dipped in fixative, the picture was repeatedly sprayed heavily, areas were scrubbed with a bristle brush, fixative was poured on areas, marbledust and finely shaved pastel were sprinkled over the picture and fixed, and experiments with water, steam, and acetone were conducted.*

Most manipulation of pastel can be categorized as heavy pressure, resulting in an even tone, or as scumbling — applying light colors with light pressure over a darker base. (See Figure 15.)

Blending. Blending pastel is simple. Using your finger or a stump, you merely mix two layers or strokes together. The smoother the surface and the thicker the pastel layer, the more evenly and easily the pastel blends. Very rough surfaces are more resistant to blending until the tooth is filled with layers of pastel. Once an area has been blended, it's very difficult to render it fresh and loose again. Layers that have been fixed are also hard to blend.

My own rule of thumb is to avoid blending as long as possible in order to retain the textural qualities of the pastel and the surface. When blending with your finger, be sure it's completely dry and grease-free. Stumps require a somewhat thicker layer of pastel to avoid picking up the pigment; they act, in effect, like brushes, collecting and spreading the thicknesses of pastel evenly. (Figure 16.)

Building Up Lights and Darks. The building up of lights and darks (Figures 17 and 18) depends upon applying ever softer layers of pastel and employing light enough pressure so that the surface tooth isn't filled up prematurely. On a smooth surface, just a few layers will fill up the tooth; on a rougher surface, more layers are possible before this happens.

However, to keep the surface tooth workable even when filled, you can take these steps:

1. Keep working in progressively softer pastel.

2. Fix the base layer to isolate it and add some slight tooth.

3. Dip the pastel stick in fixative and apply it wet.

4. Exert extremely heavy pressure on the hard edge of a soft stick, resulting in a thick deposit of pastel.

5. Sprinkle on marbledust and spray it heavily with fixative to produce a new tooth.

	Charcoal Paper **Smooth**	**Pastel Paper** **Medium**

15. *Scumbling.*

16. *Blending.*

Sandboard Medium	Fiberboard Medium	Marbledust Board Very Rough

	Charcoal Paper **Smooth**	**Pastel Paper** **Medium**
17. *Building up* *layers* *of lights.*		
18. *Building up* *layers* *of darks.*		

Sandboard Medium	Fiberboard Medium	Marbledust Board Very Rough

Studies of Nursing Mother and Kittens. *Pastel on paper, 29"× 21". These studies only serve to illustrate the adaptability of pastel for a rapidly changing subject. They combine elements of drawing and painting with stress on completing the drawing aspects in the event the pose changed before the painting was commenced.*

CHAPTER 7

DRAWING IN PASTEL

Drawing can be considered in two categories: as a complete work of art or as a guideline for later painting. There are many kinds of drawing that fall into the category of independent works of art. Although these drawings may be colored, shaded, or flat, the impressions of the drawing lines are retained and allowed to play an important part in the character of the work. Pastel is quite useful as a drawing medium because it presents a vast choice of colors, textures, and thicknesses of line. A drawing which is revised and improved in stages, and which serves as a guide for a full color, multilayered painting in pastel is called a *construction*. Such a drawing is not an outline, but rather is a series of markings denoting size, shape, angles, and position of the subject. Such attributes can be assessed in color and shape as well as in line, and while painting as well as while drawing.

Materials for Drawing. To draw in pastel I use a sharpened hard pastel that is only *slightly darker* than the tone of the surface. A very light touch is applied, and when the proportions have been roughly indicated, I switch to a slightly darker pastel and refine the drawing. This may be repeated through a third, fourth, and fifth redrawing, each time with a somewhat darker, sharper pastel until the main points of reference are fairly accurately established. The progression is from lighter to darker, from rougher to thinner, sharper, more

accurate strokes.

I find brown hard pastels particularly suitable for drawing in pastel because they provide me with successively darker shades (cocoa brown, Van Dyke brown, burnt umber, and black) for the progressive stages of line and pattern development. Figure 19 shows the materials used for drawing in pastel.

Predetermining Size. Failure to predetermine the subject's size may result in the figure growing too large for the painting or shrinking to a scale that wasn't intended. One method of predetermining the size of a subject and making it fit precisely within its assigned space is to indicate on your painting surface the top and bottom of the subject and then determine the proportions lying within these boundaries by juggling subdivisions until they're the proper, relative size. (For example, visualize a building, mark its top and bottom, then count its floors and divide the space to accommodate them.) When trying to assess horizontal proportions, it's often useful to divide areas in half to see what — if anything — falls in the middle. Then continue to further subdivide, ignoring all other aspects of the subject except to note what falls into each subdivision. Vertical proportions can be assessed in much the same way as horizontal. Again, work outward from the middle to the sides, marking and checking a small area at a time. Although verticals can't always be divided precisely in

19. *Materials for drawing in pastel: (from left to right) Nupastel black hard pastel, vine charcoal, soft charcoal, French Tendre charcoal, Grumbacher No. 28A burnt umber, and Nupastel No. 223 burnt umber, No. 283 Van Dyke brown, No. 263 Indian red, No. 253 cocoa brown, No. 204 sandalwood, No. 276 flesh pink, and No. 211 white. Above, sandpaper block; below single-edge razor blade.*

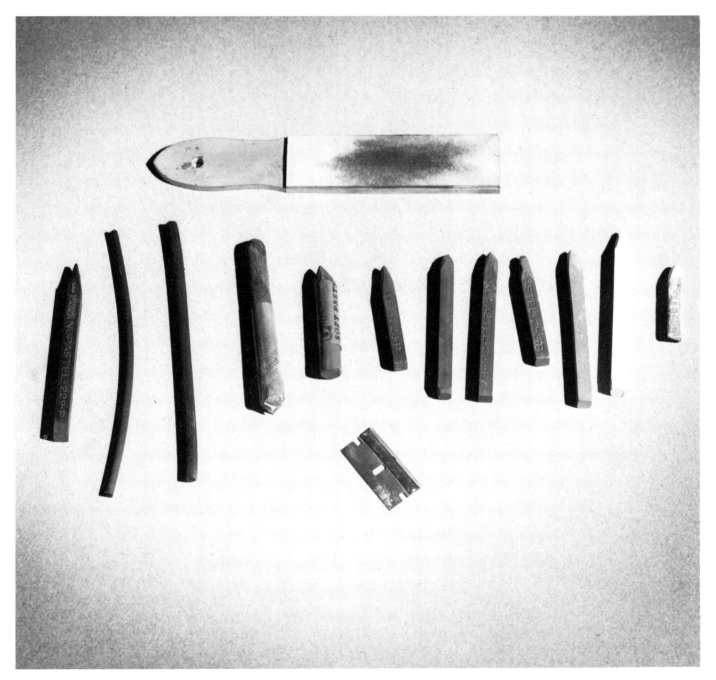

halves or thirds, they can be broken up into relative size areas to establish widths and to facilitate the placement of proportions.

Relative Sizes. In the early stages of a painting, special attention should be given to the relative sizes within the painting as a whole. Often, the parts in a painting will be individually accurate but still be too small or too large in comparison to the other parts. An example of this is a head that's too small for a body, or a hand that's fine by itself but perhaps too large or too small for the figure. Squinting helps to minimize detail so you can judge the relative sizes of color areas and lights and darks, as well as linear shapes.

Angles. One of the most important drawing skills to develop is the ability to see and draw angles. Particularly in the early stages of a painting, it's important to establish angles rather than lines, since they create a stronger drawing by emphasizing changes in direction and by adding movement. To better assess the degree of the angle, compare it to a straight line. By holding a pencil or brush exactly vertical in front of you at arm's length, you can create a plumb line against which you can check the angles in your subject. Or, seek out a straight line somewhere in your studio — perhaps a door or a window frame — and compare your angles against it.

Plumb Lines. As I mentioned before, a vertical plumb line can be obtained by holding a pencil or brush at arm's length, closing one eye and squinting. This provides you with an extremely useful tool with which to check and correct the placement of various components in the subject. For example, an imaginary plumb line dropping from the tip of the subject's nose down to the floor may cross the model's pelvis, knee, ankle, foot, etc. These points can then be marked on the painting so that they align in the same relation there as on the model. The plumb line can be arbitrarily moved anywhere on the figure to locate any additional points.

Horizontal plumb lines can be used in the same fashion to check horizontal proportions. Hold a brush or pencil in a perfectly straight horizontal line, superimpose it on the subject, then observe the areas this imaginary line bisects.

For instance, to place an ear accurately, you might hold the pencil so it aligns with the top of the model's ear, then run your eye along this straight line to the front of the model's face, meeting the top of the eyebrow. Now, by holding the pencil at the top of the eyebrow in the painting, run an imaginary straight line to the side of the head to determine where the top of the ear should be. Having checked the top of the ear, you can follow the same procedure with its bottom. Then you will know fairly accurately the length of the model's ear as well as where it should be placed.

This process of intersecting vertical and horizontal plumb lines permits you to constantly check and correct anatomical relationships.

Patterns of Lights and Darks. Consideration should be given not only to the accuracy of proportions but also to the proper placement of the light and dark patterns in the subject. These patterns are easier to see if you squint while viewing. This minimizes detail and helps you to judge shapes and values. These patterns should also be placed with con-

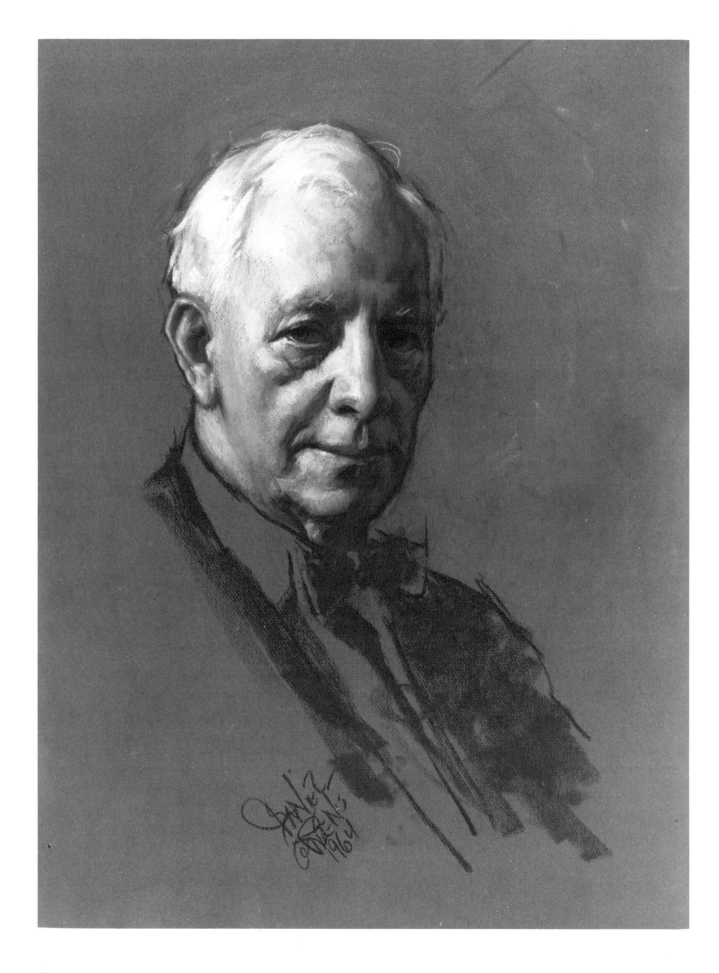

Paul Juley. *Pastel on paper, 29" × 21". Paul Juley and his father before him have operated a photographic firm distinguished for its ability to duplicate with superb fidelity the subtleties of value and color in paintings of every medium. Here I tried to simulate the lighting conditions of Mr. Juley's studio where the portrait now hangs. The pastel was applied with the side of the stick in a broad, chunky, and painterly fashion with a minimum of small, linear strokes. (Collection Peter A. Juley & Sons)*

sideration as to their height, width, and angularity through the use of plumb lines.

Linear Perspective. I can't in a book on pastel launch a fully comprehensive discussion of linear perspective — the visual phenomenon of diminishing size as objects recede. I can only deal with certain basic principles and suggest several useful guidelines for dealing with it. The factors of aerial perspective — value, color, and edge changes — are treated at length in Chapter 11 and are dealt with in every stroke.

Solving problems of linear perspective in art is predicated upon first locating the artist's eye level. A practical way of finding this line is to hold a business card at arm's length with the edge facing you, tilting it so you can see neither the top nor the bottom of the card, *only its edge.* An imaginary line running through the subject at this height represents the artist's eye level.

Objects that recede will possess lines which, if continued toward this eye level, will converge and bisect it. All such lines beginning *above* this eye level will travel downward. Lines beginning *below* the eye level will travel upward. Where these lines meet the eye level constitutes their vanishing point. Any lines perfectly parallel to your eye level will neither come up nor come down to meet the eye level, but all those *not* perfectly parallel will eventually merge with the eye level at some vanishing point. Parallel vertical lines have no vanishing point.

Drawing a box that's seen below eye level is a good exercise in simplifying the observation of slanting, receding lines. The two side planes will recede upward to vanishing points located at the right and the left on the eye level. And the front and back planes will recede upward to a point on the opposite side of the eye level, establishing a second vanishing point.

Likening objects to a box in perspective greatly facilitates observation of subtle changes in size and can help clarify the dimensional illusion. Depicting such common objects as chairs, tabletops, books, walls is a frequent pictorial problem requiring at least a basic knowledge of linear, two-point perspective. For those eager to pursue the rather involved problem of perspective at length, I can recommend three helpful books: *Perspective: A Guide for Artists, Architects, and Designers* by Gwen White, *Perspective for Artists* by Edward Laning, and *Perspective: A New System for Designers* by Jay Doblin. (See Bibliography.)

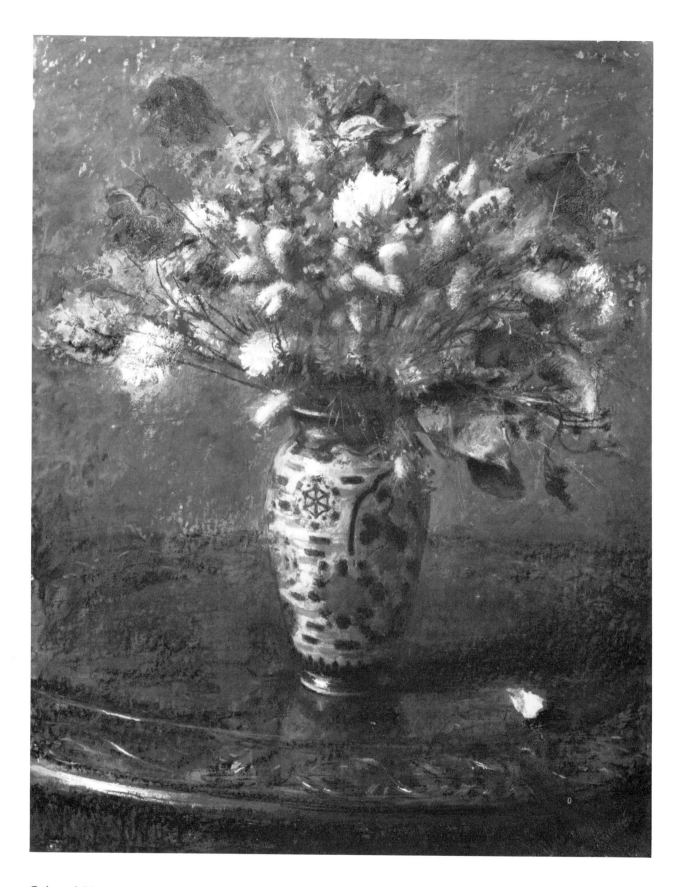

Oriental Vase. *Acrylic and pastel on sandboard, 28" × 24". Bright, nearly pure blues and rusts were established in the base, setting a strong color range for the entire painting. In addition to individual areas of chiaroscuro, the overall light and shade of the bouquet was permeated with a dark to light transition.*

CHAPTER 8

VALUES
AND
MASSES

The ability to analyze, match, and control tones allows the artist to use the medium of pastel to its fullest advantage. Values, or tones, are the relative light and dark qualities of the colors of a subject. When assessing values for painting purposes, you're actually measuring degrees of brightness or darkness.

However, it's difficult to judge the value of a color by itself and easier to do this in its relation to the other values. For instance, a pastel stick that may appear dark when lying in your box may emerge as a light tone after it's been put down on your painting and is surrounded by other, darker, contrasting tones. Naturally, the opposite is equally applicable. All colors and values in the subject and in your painting owe their quality of lightness or darkness to the colors and values that contrast with them. The relationship of values is a complicated study, but the following are ways to control what you see and what you paint.

Comparing Relative Values. To simplify the observation of values, I seek out some neutral middle tone — usually the background — and compare all the tones of the subject against this. Squinting, I note which of the subject's tones are darker than the background, which seem to match the background, and which are lighter than the background. Generally speaking, the darks will be the shaded areas farthest away from the light source. Putting these darks in first — which follows the procedure of paint-

ing dark to light — makes it quickly apparent from what direction and at what angle the light is illuminating the subject.

In any subject illuminated by a single light source, the middle tones of a modeled form will lie between the lights and the darks, but closer to the lights. The lights on modeled forms will usually fall closest to the source of light. (The term "light" is relative since even dark colors can seem light under certain conditions, such as being placed next to a much darker tone.)

Pastel has acquired its connotation of weak tints due to its great preponderance of light colors, and to the propensity of artists to use these colors to the exclusion of middle-tone and dark sticks, which are not as readily available. This results in high-key paintings without the extensive value range common to oil paintings. However, this problem can be avoided by employing the full range of middle tones and darks to scale down the tonal key of the whole painting. The light areas can be painted initially just a bit darker and stronger in color than they actually are, then slowly lightened through a series of progressively lighter strokes. Only in pastel, with its pre-mixed, graded tints and shades, can this gradual progression be so easily employed.

Starting the light areas as light, or even lighter than they appear, usually leads to chalkiness and an overworked appearance. To

continuously lighten the lights and deepen the darks is a most successful pastel approach.

Translating Color into Black and White. An additional guide to estimating values is to envision all the colors of the subject in terms of black, white, and gray. For example, a black and white photograph of a full-color subject shows its value relationships without the considerations of color. Study black and white reproductions of masterpieces for the emphasis that the Masters devoted to the proper employment of values. Most great artists of the eras preceding abstraction were extraordinarily skilled in their ability to depict natural values.

The Monochrome. Yet another means of stripping an object or a painting of color to study values is to view it through the "monochrome" or blue glass used by photographers and cinematographers. Old photographs of the famed film director C. B. De Mille show him with the blue glass dangling around his neck. This device helped him determine how the colors of a scene would appear when translated into black and white on film.

Highlights. A highlight is usually the strongest light, generally, but not always, located in the light area of the subject, lending the subject a sharp, sparkling accent. For a highlight to register in brightness, it should be surrounded by somewhat darker tones but it can be easily overemphasized in a painting if it's drastically detached from the mass of light around it.

To judge if a highlight on the subject is really strong, squint to see if it holds up or vanishes into the light areas. Then squint at your painting and see if it matches the tonal relationship on the subject.

Viewing black and white reproductions of masterpieces by da Vinci, Holbein, Ingres, and Vermeer, you may note that their highlights are barely visible or almost nonexistent in all but the most accurate photos. The great Masters were most sparing in their use of highlights. They exercised superb control over their light values, painting the masses of light and subordinating or totally eliminating the highlights.

In good representational painting, highlights are deftly placed final accents upon an otherwise completed painting. They can and should add a note of spontaneity and verve, but they lose these qualities if their shapes are excessively blended or overworked.

In pastel, a single stroke with a sharp edge of a soft pastel applied with hard pressure, or a stroke with a hard pastel sharpened to a point applied with less pressure, will usually produce an effective highlight. Very crisp accents can be achieved by dipping soft pastels in fixative, and by moistening the point of a hard pastel with the tip of your tongue.

Reflected Lights. Reflected lights usually occur in the shadow areas and are usually much lower in value than they appear, due to the contrast with dark tones surrounding them. They're generally caused by light bouncing off some shiny surface such as a wall, a collar, or any reflective surface, back onto the subject. Reflected lights can also stem from a secondary light source opposite the main source. Photographers freely employ reflected lights to cut down the density of shadow, particularly in portraits.

In painting, reflected lights can be a harsh, disconcerting note and may complicate your

value relationships. Reflected lights are usually not necessary to impart form to an object. However, if you choose to enclose some visible detail in the shadow through this device, it's best to understate rather than overstate it. My rule of thumb is to never allow a reflected light go as high in value as the middle tone. Use the squint technique to determine if the reflected light asserts itself or whether it will vanish into the shadow area. Often, a reflected light can be given a most dramatic presentation by painting it the *same value as the surrounding shadow, but in a strong, contrasting or complementary color.*

Like highlights, reflected lights are details that shouldn't markedly affect the overall tonal character of the painting. In pastel, to tone down an overstated reflected light, spray it with fixative to darken it or lighten the lighter areas of the painting to make the reflected light seem much darker by comparison.

Occasionally, a reflected light may be correct as to value and color and still seem to pop out in too forceful a manner. This may be because it's too sharply painted; fuzzing the edges of the area with your finger can tone down its aggressiveness. Reflected lights generally retain the color of the area from which they're reflected; if a light is absolutely correct as to value and degree of sharpness and still pops out disturbingly, this may be due to its brightness of color. Find some spot in the middle-tone or light areas where you can use an even stronger, brighter color that by contrast will cut down the reflected light.

Remember, to determine the actual value of a reflected light, squint again and again and assess its true value as it appears in relation to the shadow mass on the subject, then squint at the rendition on your painting.

High Key. A high-key painting is one which contains a preponderance of light colors and gives a general light impression. On a scale of white to black, most of the colors would fall into the white or the nearly white categories rather than into the black.

Much commercial illustration, particularly that painted against white backgrounds, is in high key. Artists who are known for painting in high key include Raoul Dufy, Joaquin Sorolla, Joseph Turner, and particularly, Henri Matisse. In effect, any pastel painted on white paper starts out as high-key painting because every color is darker than the paper, and the result can be very strong darks and very weak lights. (This principle can be applied any time you wish to paint a picture stressing the darks: use a light-toned paper and background to lend your darks strength and minimize your lights.) In high-key painting, the colors in the darks can be bright and rich, but there is greater difficulty in combating the chalkiness in the very pale, light colors.

The Impressionists painted in high key to achieve bright colors, particularly in their shadows. In many of Cézanne's paintings, the deepest darks are far lighter than black in value and the lights are much deeper than white. Although the effect of dramatic lighting is lost in high-key painting, a brighter, more luminous color can be achieved.

Middle Key. A middle-key painting is one in which neither the lights nor the darks predominate. This is particularly appropriate for pastel because it allows the artist sufficient

Blue Wineglass. *Pastel on sandboard,
24″ × 28″. I toned a 100% rag
illustration board with acrylic to which
I added a quantity of marbledust to
provide a rough surface for the pastel.
The combination of an extremely rough
surface and a succession of heavily fixed
layers resulted in a painting that retained
the pastel granules firmly and was least
likely to smear or suffer damage.*

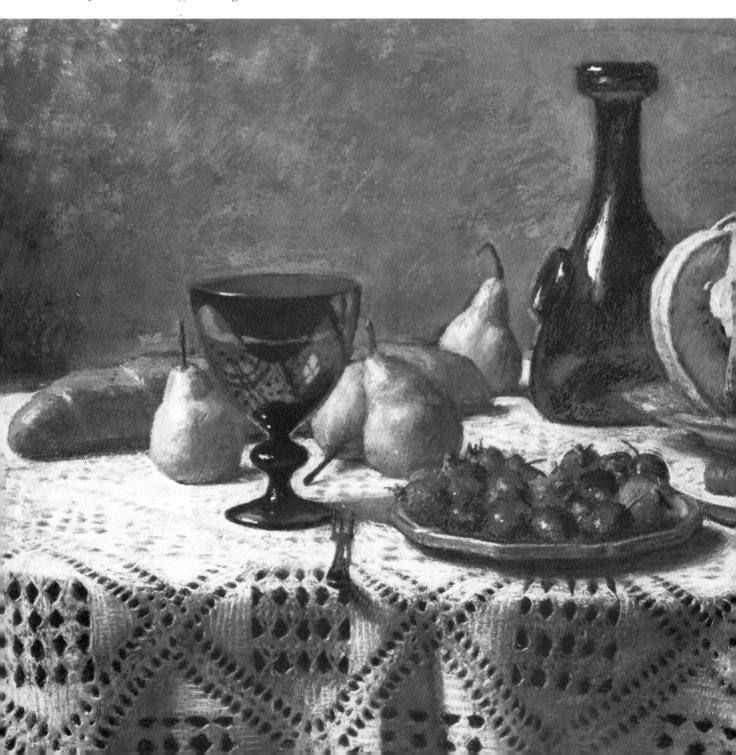

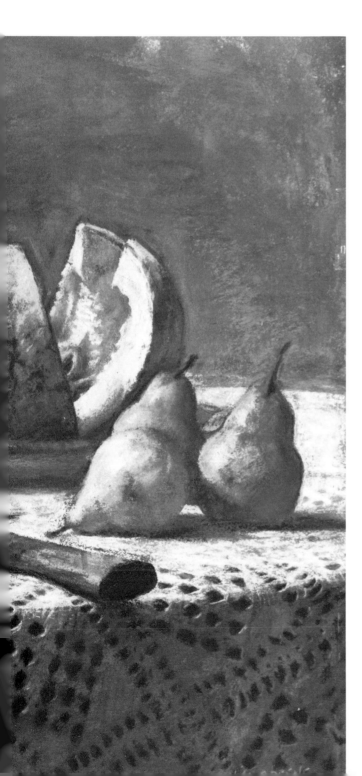

flexibility to alter his lights and darks in areas of the painting without tipping it completely toward the high-key or the low-key category.

Painting a middle-key picture on a middle-tone paper provides the artist with a full range of colors that are lighter and darker than the paper. He can thus achieve bright color in either direction, and has enough sticks to choose from to gain his ends.

However, the danger exists that middle-key painting lacking positive lights and darks will emerge flat, bland, and lifeless, so you should try to establish some good contrasts to avoid too limited a value range.

Low Key. A low-key painting is predominantly dark in value. Due to the overall lowered key of the painting, the lights can be brighter, richer, and deeper. However, due to the shortage of good, rich darks in most pastel sets, it's very difficult to paint the dark areas in a low-key painting as colorfully and deeply as necessary to achieve strong contrasts. Since the light areas always predominate in a low-key painting, it's best if these are the most interesting and important parts of the subject.

A Note on Black Pastel. It's useful to remember that spraying fixative over an area painted in black pastel can render that area *lighter, not darker*! This can be used to advantage, creating, in effect, a passage painted in what appears as a very dark gray, allowing new accents in black pastel. Blacks differ in darkness in the various sets, and by fixing and reworking with an even blacker black, an artist can achieve additional depths of rich, dark value, while gaining still further extension of control of the white to black range.

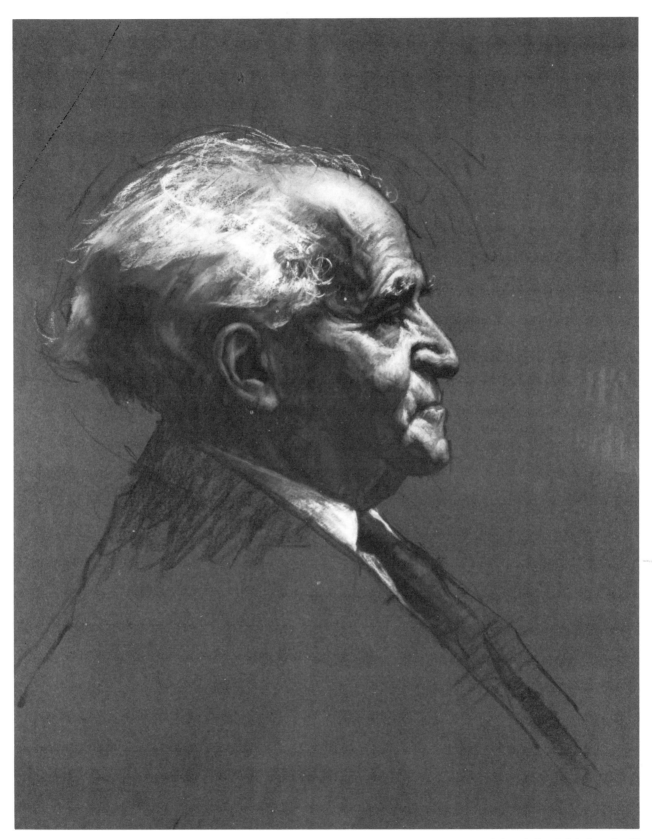

David Ben Gurion. *Pastel on paper, 29" × 21". The late Premier of Israel had a superb head that I felt lent itself best to a profile interpretation. The technical problem such a portrait presented was how to coordinate the anatomical detail with the strong patterns of light and dark. Two-thirds of Mr. Ben Gurion's head lay in deep shadow, therefore the lights had to be bright and aggressive enough to compensate for the great areas of shade. (Collection Mr. and Mrs. Charles Plohn)*

CHAPTER 9

COLOR

Over the years I've worked out an approach in which I use certain points of reference to analyze the colors I see in my subject, and to transpose these colors to my painting.

Warm or Cool. Starting with the most obvious areas of warm or cool colors, I first determine the value of a particular color area, then decide whether it's basically warm or cool. Based on these observations, I tentatively select from my trays a stick of approximately the same value, hue, and degree of warmth or coolness as the color I'm trying to match. With this stick I make strokes in the appropriate area, as a kind of shorthand note indicating that that particular part of the painting falls into the cool or warm side. I can then use these areas as a reference against which I compare the subtler, less-obvious areas of color.

For my purposes, the warm colors are the yellows, reds, oranges, golds, and warm purples; the cool colors are the blues, greens, grays, and raw umbers. Although within these categories there are further subdivisions such as cool reds (pinks) and warm blues, the basic category of a color is unaffected — all reds, whether warm or cool, remain within the warm category, and all blues, whether warm or cool, remain within the cool category.

You may discover (as I have) that you change your mind about the hue of these colors from one painting session to the next.

However, while the hue may seem different, its category of warmth or coolness does not vary.

Blue or Yellow. The next step in my scheme is to decide whether these warm or cool areas fall into a blue or yellow category, that is, to decide whether these areas have a yellow tinge or blue tinge, due to the quantity of either color used in the pigment mixture. If the original shorthand note was of a basically *cool color* such as green, I would then determine if it is a *yellowish* green such as olive, permanent green, or chrome green, or a *bluish* green such as viridian, turquoise, or sea green.

Even grays, which are basically cool in color, can tend to the blue or the yellow side. Those grays made of mixtures of only black and white tend to be cool with a slightly bluish cast. However, grays made with black, white, yellow, tan, umber, or gray-green tend to be yellowish and warm.

Browns, too, either consist of the orange-red-browns, which are in the yellow direction, or the blue-reds and purplish browns, which are in the blue direction. The blue-green-browns and the gray-browns are assigned to the blue category, while the gray-yellow-browns and the yellow-green-browns lean toward the umber-yellow category.

At this stage, a stroke of what seems to be the correct stick will help you to quickly assess how close you are to the color you see in the

subject. If it doesn't seem right, search for a stick that matches better by judging the difference between the color you've used and the color in the subject.

It's my experience that in the middle tone and light areas, it's better to err slightly toward the darker and brighter color than to use too light or too weak a color. I recommend deliberately using extremely rich, warm and cool colors in the middle-tone areas to minimize any chalkiness when you later work into the light areas.

As I select particular colors during the painting, I put them aside so I may use them over and over again. I've found that many colors reappear in various areas of the subject; it's rare that a color is found in only one area of the subject.

Keeping Colors Rich.

I don't recommend toning down or weakening colors. I prefer to use the richest, brightest color available. Then, if any neutralizing is necessary, rather than tone down the bright color with lighter, weaker shades, you can minimize its impact by stroking its opposite (warm over cool or vice versa) over the too-forceful areas, resulting in a relative neutrality while still employing rich colors.

Isolating Color Areas.

I've found it most helpful during the course of a picture to periodically stop and run a series of selective visual checks, then to match my findings to the painting.

I do this by temporarily isolating my vision and confining it to one area of color at a time. I scan the subject for all *cool* color areas only, ignoring the warms, then match it against the *cool* color areas in the painting, checking for accuracy. Then I repeat the procedure for the *warm* areas, or for the hue groups only — all reds, or all greens. I might even simplify my vision further by scanning only the cool grays, then only the warm grays. When isolated from other considerations, the aspect under scrutiny registers with particular impact and facilitates correction. It requires concentration, but can result in an overall improvement of the painting.

Additional Notes on Color.

It's worthwhile to keep in mind the principles regarding the role of color in making objects seem to advance and recede, and by employing the appropriate warm and cool colors to encourage this illusion.

I've found that in painting portraits and figures, there are warm and cool areas of color present in the light, middle-tone, and dark areas. I therefore don't recommend painting shadows or lights all cool or all warm, in a predetermined way, but following colors as they appear in the subject and then developing color relationships and harmonies as the specific picture requires.

Generally speaking, the subject in a portrait or a figure study falls into a predominantly warm or cool category. I find this consideration helpful in guiding my choice of color in the background and clothing. A model tending toward a cool coloration would motivate me to use warm tones in the background, as a contrast.

The colors I use in my pastel work change from painting to painting. They depend entirely upon the subject. I make my selec-

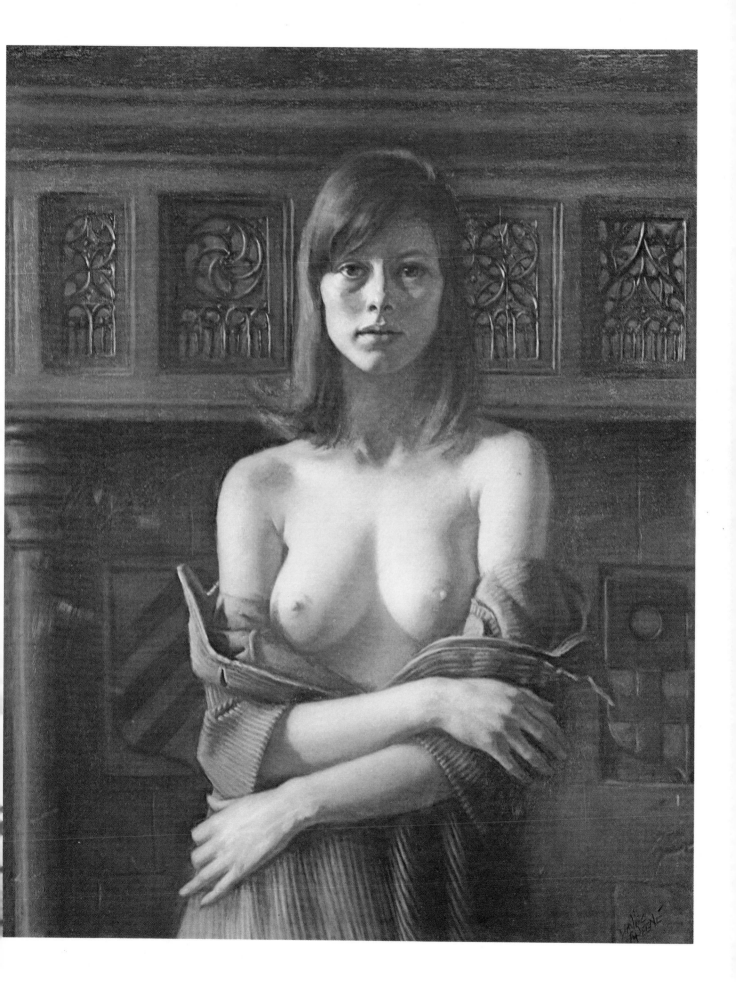

121

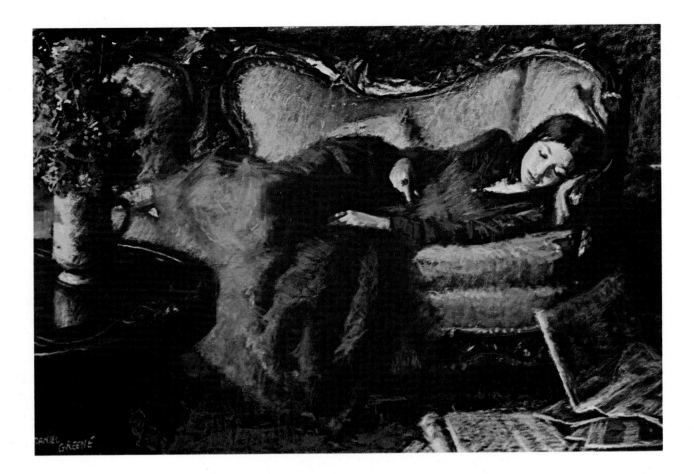

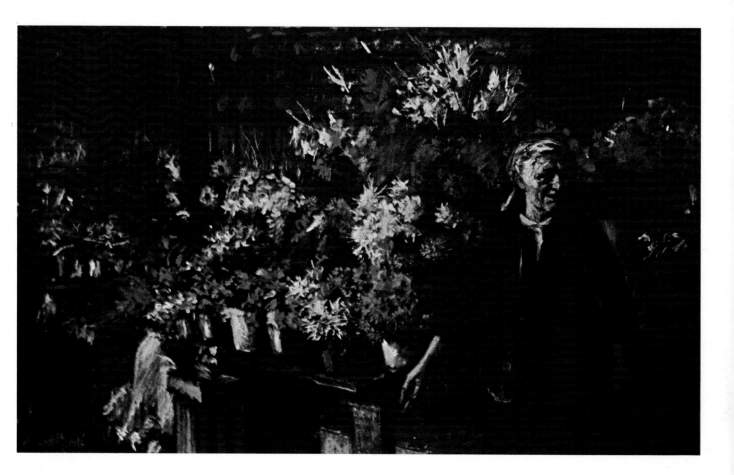

Sunday Times (Above Left). Pastel on sandboard, 12"
× 20". Due to the small scale of this painting, I used a
combination of soft pastels, sharpened hard pastels,
and pastel pencils. First I painted large masses with soft
pastels applied lightly, then I proceeded to register the
smaller details with harder pastels applied heavily. The
table was included late in the development of the paint-
ing to provide additional depth and to help break up the
vertical action of the couch. (Collection Mr. and Mrs.
David Kluger)

Gustave Cimiotti (Left). Pastel on paper, 29" × 21".
Gus Cimiotti was eighty-nine years old when he sat for
this portrait. A landscape painter who had been a par-
ticipant in the original Armory Show in 1913, he
worked right up to the very last day of his life, which
ended at the age of ninety-four. Gus was a proud,
forceful figure and I chose to present him in a charac-
teristic attitude of assurance and determination. The
design and pattern of the white hair and beard gave me
an opportunity to achieve lots of action in the portrait
even though it was only a painting of a head. (Collec-
tion Mr. and Mrs. Charles Plohn)

Parisian Flower Vendor (Above). Pastel on sand-
board, 12" × 20". While visiting in Paris, I deliberately
sought out the flower market in anticipation of images I
might adapt for future paintings. I selected this view
with juxtaposed figures and plants as a subject I could
treat naturally without rearranging any of its aspects;
such peripheral items as crates, stone columns, and
signs would have been nearly impossible to invent in a
studio situation. (Collection Mr. and Mrs. Louis Weiss)

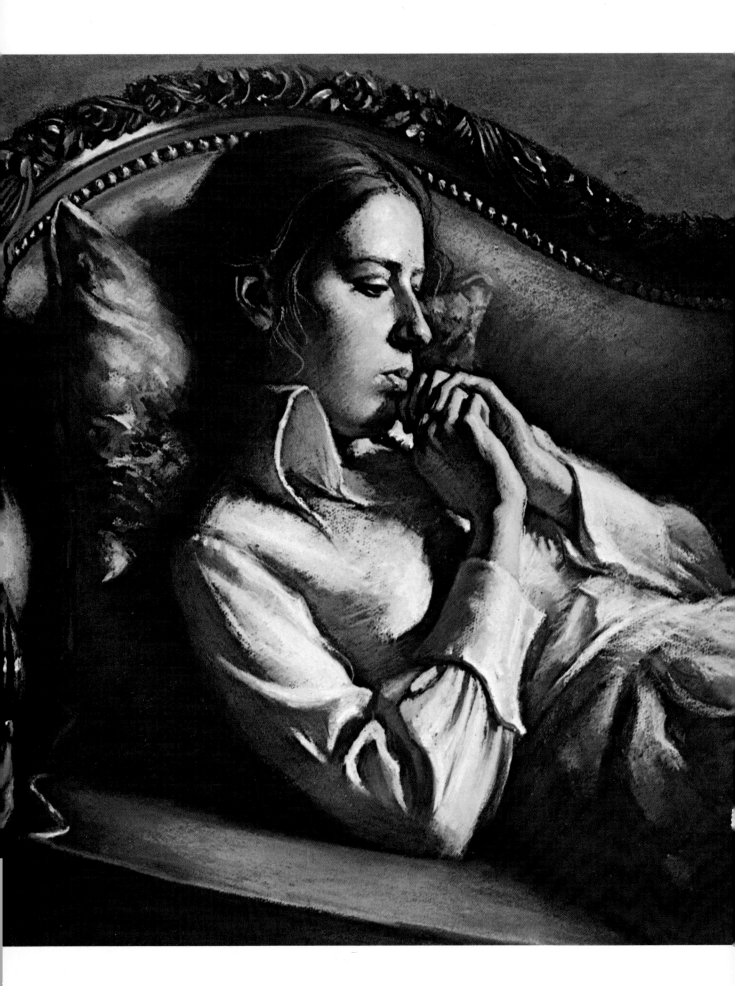

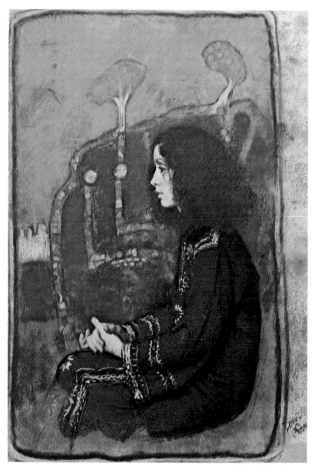

Carina in the Park *(Above). Pastel on paper, 29" × 21". Both realistic and expressionistic renditions are at work here. I employed a wide range of textural pastel techniques — both modeling and flattening the figure, and dividing the color combinations into foreground, middleground, and background, as in Gothic paintings. I gave the paper a stainlike appearance through a mixture of blending and painting directly with heavy pressure. (Collection Mr. and Mrs. James R. Dunn)*

Michele Resting *(Left). Pastel on paper, 21" × 29". The painting was preceded by an accurate charcoal drawing, then fixed. I established large areas of shadow throughout the composition, registered the dark colors, and then indicated the light patterns. The blouse and skirt were painted without using any white, saving the final accents for touches of white soft pastel. (Collection Mr. Thomas Charack)*

Model Resting (Right). Pastel on paper, 40" × 32". Following a long and difficult posing session in which I sought to find an interesting pose, I gave the model a rest period and he assumed this pose which I immediately adopted for the painting. Since the very deep shadows on the shirt and bag required darks that my sets couldn't provide, I made some dark green and dark blue pastels. These allowed me to paint deep and colorful tones that, by contrast, would permit richer, brighter colors in the adjoining light areas. Painting the very complicated masses of Ron's long and wavy hair required careful control of the overall dark, middle-tone, and light values of that area.

Yellow Drapes (Below). Pastel on sandboard, 12" × 20". A painting done in back, or rim, lighting is easy to do since this kind of illumination clearly delineates the masses. However, the artist must turn his easel in such a way that he doesn't face the light directly because this would make it extremely hard to see colors. (Collection Mr. Victor Kluger)

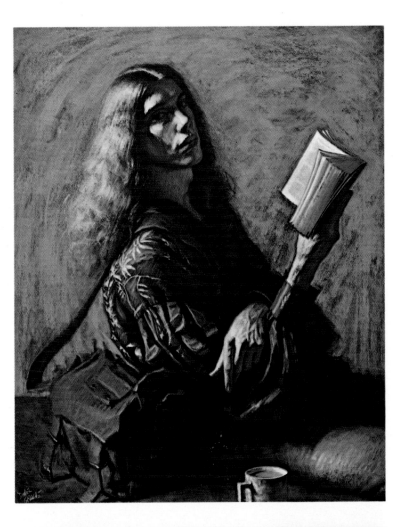

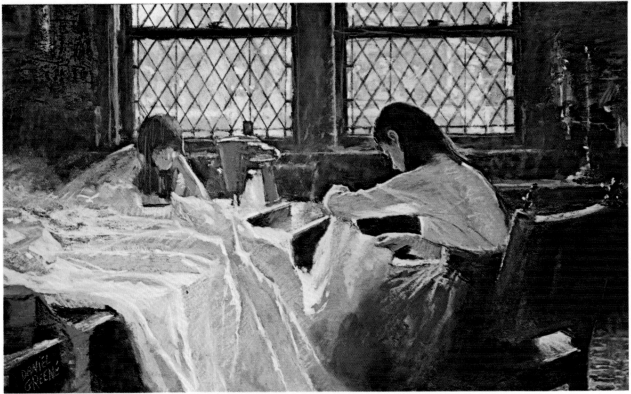

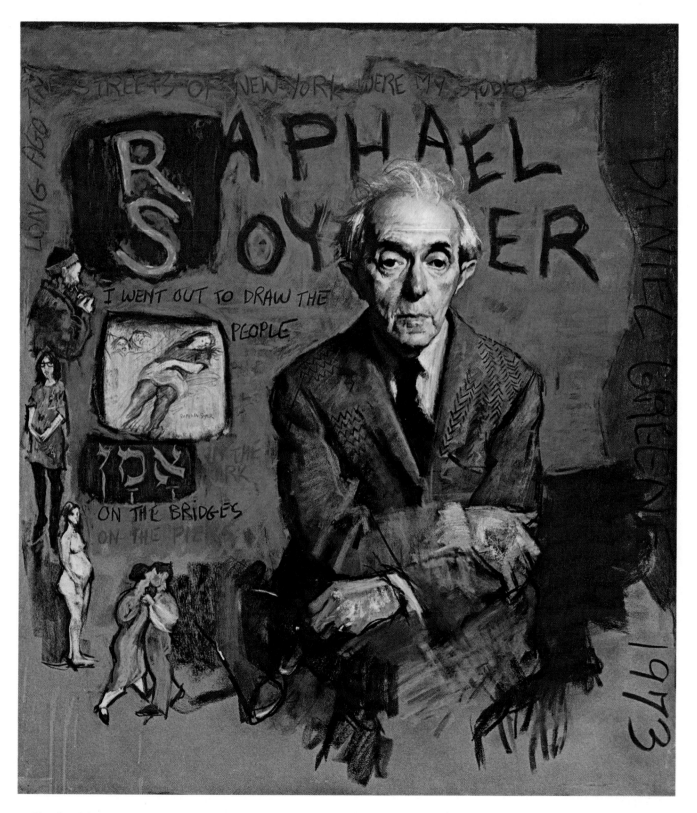

Raphael Soyer (*Above*). *Pastel on paper, 41" × 47". The sheet used for this portrait was cut from a roll of Canson Mi-Teintes paper, ironed flat, and clipped to a plywood board. I made no effort to pose Raphael (who, besides being an artist of enormous ability and international renown, is a good friend) since he presents an interesting appearance no matter what pose he strikes. I wasn't as concerned with getting Raphael's likeness as with trying to achieve a spontaneous, unfinished effect. The hands and figure were executed simply to establish this gesture rather than to attain a realistic rendition. Raphael's face, which has been painted and sculpted many times, reflects the feeling and sensitivity that are traditionally attributed to artists. He really looks the part.*

128

tions for a particular painting in its early stages as I determine the color harmonies and combinations of the subject. This results in a more spontaneous painting than one produced from a rigid, fixed palette. Each new painting presents new and interesting problems rather than a repetitive color scheme. The effort to see and match colors can open a vast and exciting visual experience and eliminate the frustration that comes of just guessing what colors to use. Through practice, distinguishing colors can become an easy, though important, artistic skill.

The Artist's Wife. *Pastel on paper, 29" × 21". This portrait was executed as a demonstration for a book. The original concept emphasized the head and ruffled collar of the blouse, but the painting underwent many dramatic changes, including painting a jacket, changing the background color, subduing the modeling in the hair ribbon, and shortening the ruffle. Although the figure drifts into the background in several areas, no blending, rubbing, or fusing was used — I did this by matching the values closely and by altering the degree of pressure in the strokes. (Photograph courtesy Portraits, Inc.)*

Thomas Flournoy. *Pastel on paper, 29" × 21". This profile pose with its preponderance of shadow, was particularly amenable to a rigorous procedure of value progression running from dark to middle tone to light. The dark-toned paper was allowed to strike through and to serve as a middle-tone value in areas such as the neck, and as a kind of pebbly transitional value between the lights and the darks, where it was partly covered. (Private collection)*

MODELING FROM DARK TO LIGHT

In the ideal single light source situation, the shaded parts of the subject are farthest away from the light. This type of lighting has been traditionally employed by artists through the centuries and has been a subject of study by such masters as Vermeer, Caravaggio, Rembrandt, Raphael, and Sargent. I've found that likening the initial stages of a pastel painting to a black and white drawing immediately identifies the direction of the light and provides valuable information as to the basic structure of the subject.

My procedure for working from dark to light is to apply all the darks, making them somewhat larger than they really are. Then I develop the middle tones next to the darks, "chopping" away at their edges. Where a discernible light appears on the subject, I begin to develop the light tones in my painting, chopping away excess middle tones. This is much more effective than painting areas exactly to where they end and then carefully fitting the boundaries together, since the chopping-away method creates a loose, painterly appearance, while the fitting-together method produces a tight, mechanical sort of drawing.

By using this method and putting down all your darks accurately in value, all your tones should be related in a proper sequence. This is because the middle tones are based on the values of the darks, and the lights are based on the values of the middle tones. Working in reverse, from light to dark, can lead to difficulties because you base your values on the lightest areas, and so the edges where the lights meet the middle tones and where the middle tones meet the darks emerge *too* light.

Pastel, due to its premixed, graded, wide range of available colors, is particularly suited to notching ever-lighter tones out of the darker values. The dark-to-light system is also the most successful method of pastel painting because when you apply dark over light the lighter underlayer acts much like wet paint and intermixes with the darker top layers, creating a chalky appearance and robbing the darks of their full-value strength and color.

Of course, many separate considerations must be dealt with simultaneously while painting. Periodically concentrating on one facet of the picture at a time, to the exclusion of other considerations, simplifies the organizational aspect of composing a picture. The dark-to-light method greatly facilitates this procedure.

Keep in mind that if a light area grows too light, it can be toned down with a spray of fixative and then restated. But since the dark parts are the key to establishing the other values, they should be completely prepared so you can then rapidly lay in the middle tones without breaking the sequence to stop, hunt out, and put down any additional, overlooked darks.

The following demonstration shows the modeling of facial forms from dark to light.

Step 1. *Using a hard brown pastel, I quickly draw an eye, nose, and mouth, putting special emphasis on angles and directions, with some slight indications of shadow, and defining the shape of the edges lying between the lights and the darks.*

132

Step 2. *Here I mass all the shadows in the appropriate warm and cool colors, registering some distinction between the relative degrees of darkness. This is deliberately executed in somewhat broken strokes and with heavy enough pressure to fill the tooth, preparing a soft velvety surface for the succeeding darks. I "chop" the middle tones out of the edges of the darks, and extend them farther to the left than they will ultimately be.*

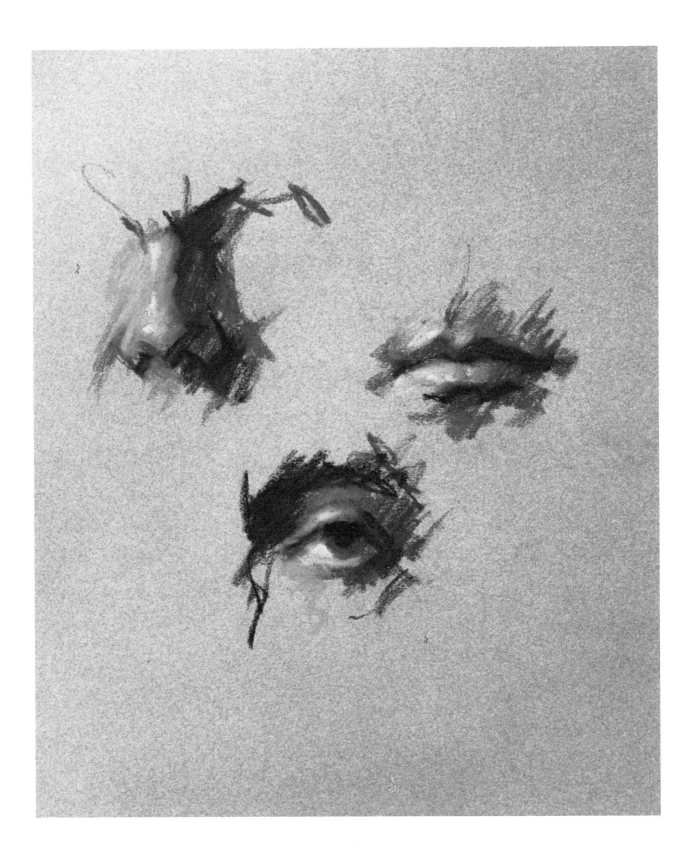

Step 3. *Next I "chop" away at the edges of the middle tones with lighter values as the modeling continues from right to left. Warm and cool colors are simultaneously registered and highlights added, using medium pressure.*

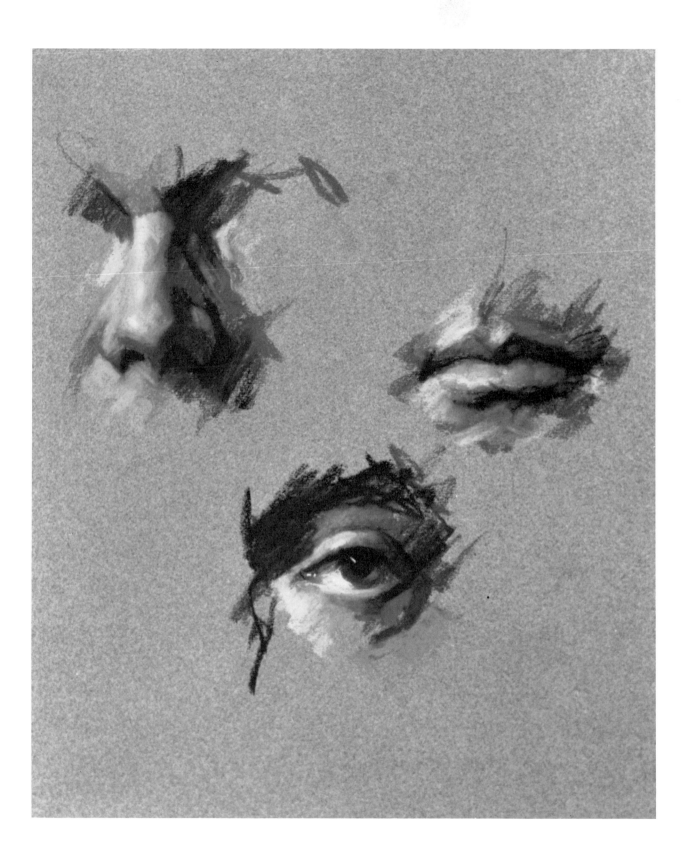

Step 4. *I repeat the dark-to-middle-tone-to-light sequence, employing stronger drawing, richer colors, and heavier pressure. I pay special attention to sharpening those edges where the forms should come forward, and softening those where they should recede. I apply the sharp edge of the pastel with heavy pressure for the crisp highlights, and the blunt tip with less pressure for the softer highlights.*

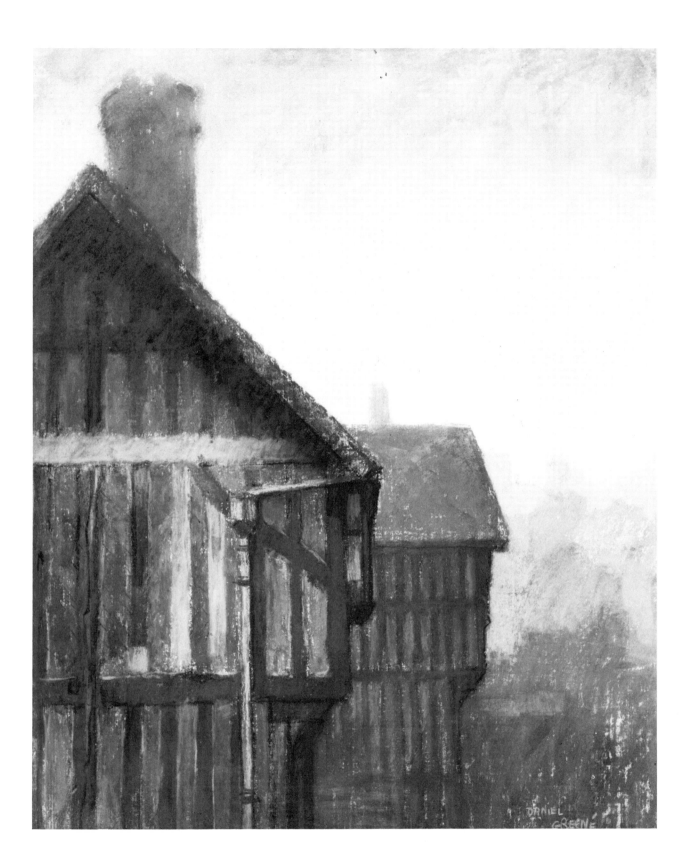

Tudor House. *Pastel on sandboard, 24″ × 20″. To make the image seem visually accurate, I painted the front objects darker, sharper, and brighter, using warmer and richer colors, and reserved the cooler, lighter, duller values for the progressively receding planes. (Collection Mr. and Mrs. Wm. H. Steele)*

CHAPTER 11

MAKING OBJECTS ADVANCE AND RECEDE

The illusion of objects seeming to advance or recede on a flat surface is called *aerial perspective*. This principle is most easily understood if one imagines a landscape with mountains many miles distant in the background, and a tree in the immediate foreground. Those objects closer to the viewer, such as the tree, will be sharper in focus, stronger in contrast, richer and warmer in color, with lighter lights and darker darks, than the mountain.

These same visual principles apply to everything you see, and they can be incorporated into every painting. Whenever you want an area in your painting to advance, paint it sharply, in strong contrast, with rich colors. Apply the same principles in reverse to those areas you want to recede. Each stroke you employ, no matter how spontaneously, should incorporate the concepts of aerial perspective; whether the stroke will be crisp or soft should be predicated on the effect you're hoping to achieve — near or far.

A good practice in planning a picture is to save the *very darkest* and *very lightest* accents for the final stage of the painting. This will allow you to decide what areas you want to advance or recede when all other factors of the painting have been solved. To make *one object* recede into the distance, you can either paint everything in relative focus then sharpen the front areas, thus making the rear areas *seem* blurrier by contrast, or paint the distant areas blurry right from the very beginning.

The Gothic painters depicted everything in their pictures in sharp focus, no matter how distant the object. Velásquez was among the first to notice and exploit the phenomenon of aerial perspective. He observed that objects viewed individually were in sharp focus, but that all peripheral areas were blurred. He painted his portraits accordingly — the face and part of the figure sharply, the rest in a loose, out-of-focus, Impressionistic manner.

Remember, deal with the painting as a whole, and then increase the contrasts, sharpness of edges, strongest lights, and deepest accents in the areas that are to advance *as a final step.*

Fox Tracks in the Sand. *Pastel on paper,
21" × 29". The setting of this painting was
the beach, with strong shadows cast by the
sun hitting the forms at an angle. I wore
sunglasses to cut down the glare and
stopped often to wait for the clouds to
pass by. I carried the full assortment of
pastels — quite a burden treading through
the soft sand. I subsequently learned to
carry only a limited selection on my
outdoor assignments. (Private collection)*

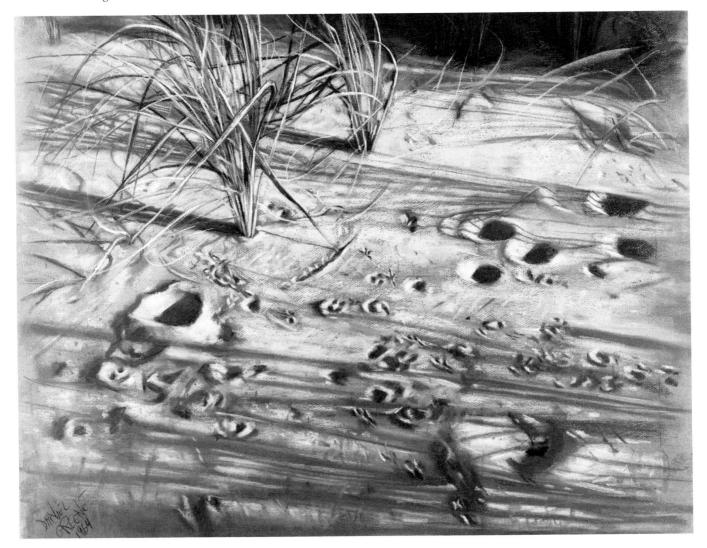

Boat on the Beach. *Pastel on paper, 21" × 29". The strong horizon line was deliberately placed higher than mid-center, then broken by the outline of the boat. To provide a dramatic contrast to the lighter areas, the values of the foreground and water were painted darker than in reality. I used hard pastels for the details in the foreground and boat and stroked the light, crisp accents into the field with the edge of a soft pastel. (Collection Mr. Charles Plohn)*

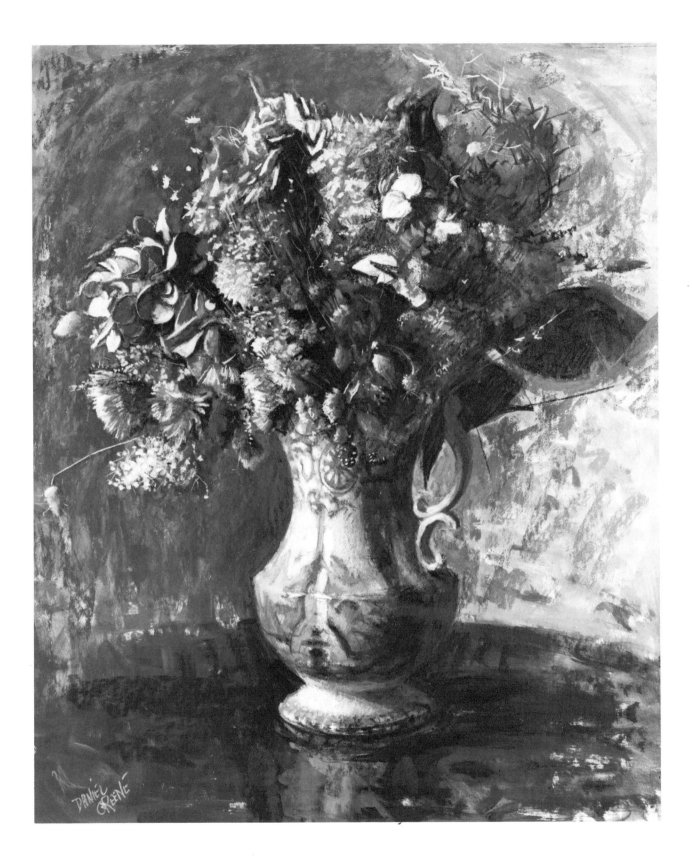

Flowers in a Delft Vase. *Pastel on sandboard, 28" × 21". I was struck by the variety of colors and shapes in this bouquet of dried flowers at a friend's house and borrowed it to make this painting. Under the north light of my studio, I arranged the subject so the varying shapes and textures of the leaves and flowers were accorded the most dramatic illumination. I made a rapid underpainting in acrylic to work out compositional problems, leaving sufficient texture for succeeding layers of pastel. (Collection Mr. and Mrs. Leon Weiss)*

CHAPTER 12

MIXED MEDIA

Pastel can be successfully applied over other non-oil media, adding its own opaque, splattered, broken, scumbled, scintillating qualities.

The prime requirements for painting in pastel over other media are that the surface should not be at all oily, and that it should possess sufficient tooth to hold the particles of pastel. Often, the rough texture of the paint itself — gouache, casein, or acrylic — will provide this necessary texture even though the underlying surface is a smooth board or paper.

Advantages of Mixed Media. The advantage of combining pastel with such media as watercolor, gouache, casein, or acrylic, is that these aqueous media can cover large areas quickly, and even after many coats, still provide sufficient tooth for overpainting with pastel. This permits you to correctly establish patterns of lights and darks, to lay a kind of blueprint of complementary colors and values to be later deepened or lightened with pastel, to work out compositional problems, and to avoid an overworked appearance which might result from building up layers of pastel while making these changes.

An underpainting in another medium can provide a non-soluble toned ground which will not intermix with the overlayer of pastel. (Pastel applied over pastel does intermix somewhat.) Therefore, pastel painted over a non-pastel medium base can be applied with heavier pressure and still retain its crisp, splattered appearance, and can be applied in a semicovering manner, allowing the ground colors to strike through for color or value contrast, much like working on a colored paper. Of course, you can deliberately paint a pure, brightly colored ground, establishing a rich color range so that the brightest, richest pastels may be used to match this degree of brightness.

Combining the liquid, flowing, washlike characteristics of paint with the crisp, splattered effects of pastel *during* the painting is another possibility, which exploits the best of two different yet complementary media. With paint, you can indicate the thinnest, most precise lines — such as telephone wires — that are difficult to accomplish with pastel on the normally rough pastel surface. You can easily add tooth to your painting surface by combining granular materials with your paint before or while working in pastel. Also, with paint you can establish very deep darks, especially the blues and greens that are often lacking in commercially manufactured pastel sets.

When Mixed Media. I decide whether to work solely in pastel from the beginning of the picture or to underpaint with another medium by making a rapid analysis of the problems I anticipate in the painting. My fast rule of thumb is: for rapid, direct pictures — pastel; for flexible, complicated pictures with many revisions — mixed media.

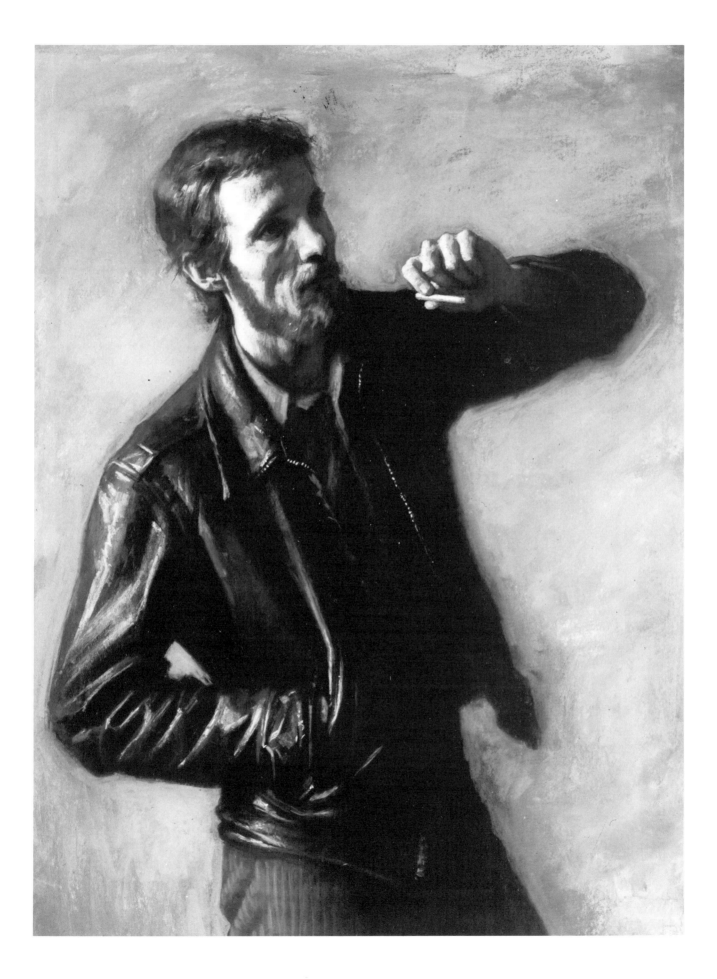

Which Media Best with Pastel. My first choice for a medium to combine with any pastel painting is acrylic paint because it is opaque, dries fast, doesn't lighten excessively upon drying, and holds marbledust firmly to the painting surface. My next two choices are gouache and casein, which are also opaque and can be used on toned surfaces. I seldom use watercolor, since its transparent quality requires a white rather than toned ground.

Some Technical Considerations. I use aqueous mediums on board, but rarely on paper since it would buckle. The thicker the board, the less likely it is to warp; to make sure it doesn't, I clamp it very securely to its backboard. If the surface of the board isn't rough enough, or if the aqueous medium is applied too thickly and evenly without any marbledust or other granular substance, the surface might be too smooth to accept pastel. Likewise, very heavily applied fixative has a leveling, shiny character that may resist pastel.

Another thing to remember is that spraying the surface with fixative before applying the pastel may brighten the painted base; a casein or gouache tone seems to brighten less from fixing than does acrylic.

One further thing to remember is to let the underpainting dry thoroughly before proceeding with pastel. This is usually a matter of 45 minutes to an hour, depending on the absorbency of the surface and the amount of water and paint used.

Bill Smoking. *Pastel on matboard, 40" × 30". The smooth, white matboard was first toned in acrylics, sprinkled with marbledust, then fixed, providing a roughened tooth for the pastel. I also used acrylics to work out some initial problems of drawing and composition, then switched to pastels. To obtain a dark enough black for the jacket, I went from soft charcoal to very dark gray to hard black pastel to soft black pastel. Spraying brought the blacks up somewhat enabling me to repeat the darkening process again and again. (Collection Dr. Gerald Levi)*

Waiting. *Pastel on paper, 14" × 20". This is a very quick color sketch done in perhaps fifteen minutes without the model's knowledge. I used a limited, predetermined number of pastels of strong, pure hues. In the context of abstract shape, the vignette seemed successful from the very first with its staggered, assymetrical contours. The rather staccato pattern of highlights on the top of the sofa lead, much like a rocky path, to the head. (Private collection)*

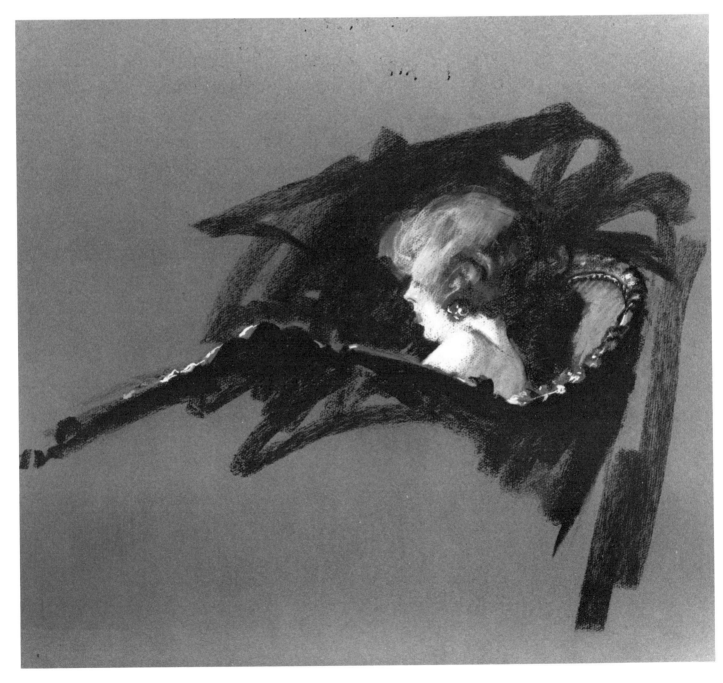

RESTRICTED PALETTES

I constantly stress to my students the need to acquire the largest possible assortment of pastels so that they will never have to compromise by substituting a less-accurate, less-bright, less-rich, less-dark color for the one actually needed.

A limited number of necessary pigments in oil painting makes very good sense; the intermixed colors have a built-in harmony and a reduced palette can easily produce thousands of mixtures. However, in pastel all the mixed tones must be present in individual stick form, and intermixing to achieve changes of color is very limited.

My main objection to a restricted pastel palette is — besides compromising your choice of colors — that a limited assortment tends to force the artist to use repetitive patterns of painting that may be detrimental to his growth and development, particularly in the area of portraiture.

Unless this constitutes a means of experimentation or control of a special picture problem, there's nothing less creative for the artist than to turn out routine paintings that resemble all the other paintings he has done in the past.

However, there are occasions when you wish to reduce your palette to more manageable levels. When this reduction is deemed necessary, it's best to begin with the absolute minimum of required colors and to add all those colors and shades that you can't do without, until you arrive at the next best substitute for

a complete assortment.

One method of reduction is to choose a light, middle tone, and dark of the minimum colors you absolutely must have, then add one warmer and one cooler version of each light, middle tone, and dark. This palette can be enlarged by any number of additional lighter and darker values besides the three initial tones.

When a Restricted Palette.

A restricted palette may become necessary when painting a rapid portrait, when trying to capture fleeting effects of nature, such as a changing light or a cloud formation. It's also necessary when painting outdoors or while traveling, in which case a full assortment can't be transported.

Kinds of Restricted Palettes. There's no limit to the ways in which palettes can be limited or restricted, especially when you consider the color and tone of the paper as an additional element. Here are some starting points for limited, special-purpose palettes:

1. *Black, gray, and white.* This palette provides an elementary dark, middle tone, and light, enabling you to explore form and value without the distractions of color. It can be further amplified with a warm and cool gray, and a light and dark gray.

2. *Shadow tone and white on toned paper.* The paper serves as the middle tone and the shadow tone as the dark, while the white provides the light values. This palette was much used by

Caput Mortuum. *Pastel on fiberboard, 30" × 40". Antique toys and other objects were selected from my children's room, then carefully arranged to give the impression of casual disarray. The lights of the forms were composed to stress thrust and action. A limited palette of harmonious somber colors was selected to reinforce the dark mood as a contrast to the agitation of the light shapes.*

the Masters, who drew on toned paper with charcoal or red chalk and heightened with white. Dürer, Holbein, Delacroix, Daumier, Raphael, and Rubens all were exponents of this method.

3. *Black, red, and white.* The black is the dark, the red is the middle tone, and the white, the light; this palette is used essentially for portraits.

4. *One warm and one cool* of a dark, a middle tone, and a light in a single color.

5. *Warm red, warm gray, and warm ochre.* This is a three-stick *warm* portrait palette which can be expanded to include a full range of shades in red, gray, and ochre.

6. *Cool pink or purple, cool blue or gray, and cool ochre.* This is a three-stick *cool* portrait palette which can be expanded to include a full range of shades in pink or purple, blue or gray, and ochre.

7. *Full range of values of any single color.* Such a palette would have all shades of a blue, red, green, etc.

8. *Impressionist palette.* Pure primary colors and tints only, excluding all blacks, browns, earth tones, and grays.

9. *Limited tonal range palette.* Obtained by reducing the range from light to dark so that the darkest dark is much lighter than black and the lightest light is much darker than white. Cézanne employed such a palette, which provides sufficiently rich color but narrows the range of contrast between the tones.

10. *Color spectrum palette.* Limiting the colors to only those basic twelve listed on the color

146

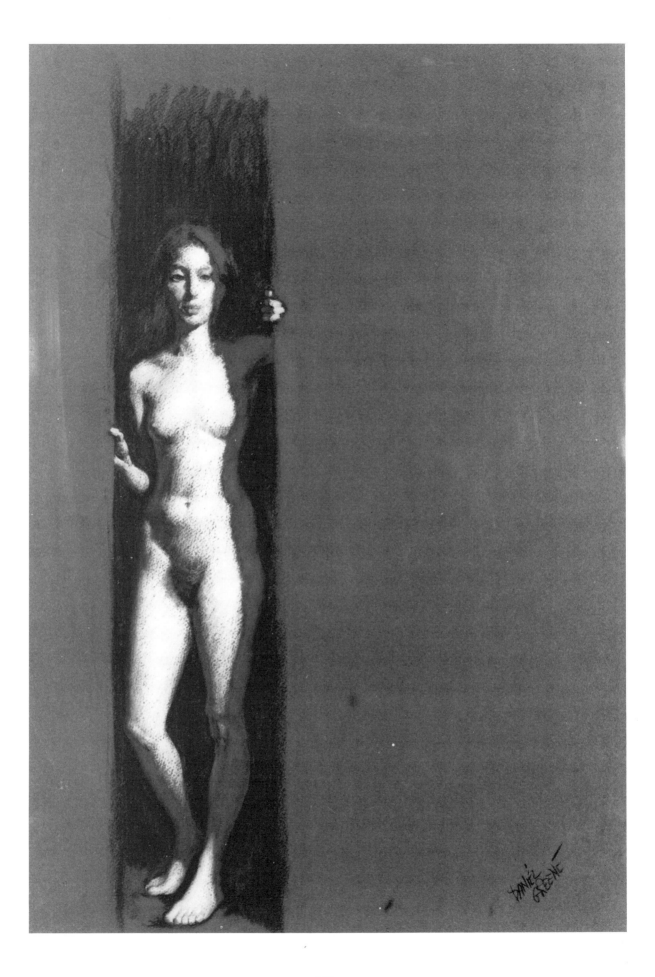

wheel — yellow, yellow-green, green, blue-green, blue, blue-violet, violet, red-violet, red, red-orange, orange, yellow-orange.

11. *Pointillist palette.* Using blue and yellow to create green, and red and yellow to create orange, or creating other optically mixed color combinations.

12. *One-color palette.* Using the tone of the paper as one color (as for instance the blue of the sky), and a light and dark of the same color.

13. *Three-tone, three-color palette.* Using a light of one color, a middle tone of a second color, and a dark of a third color.

14. *Portrait palette.* I have also devised a restricted palette for skin tones to be used in rapid portraiture. The palette (which can be amplified by oranges and browns) consists of the Grumbacher soft pastels No. 28A burnt umber and No. 99M red-brown-ochre, Nupastel No. 223 burnt umber, No. 283 Van Dyke brown, No. 253 cocoa brown, No. 204 sandalwood, No. 276 flesh pink, No. 211 white, and black, and the Carb-Othello pencils in the following shades: Indian red, white, light gray, dark gray, sanguine, deep sanguine, and black.

In the Doorway. *Pastel on paper, 20" × 14". The extremely elongated vertical light pattern running nearly the length of the model's figure posed the interesting problem of how to reproduce the colors and values of the cast shadow. Additional considerations were the size and placement of the lights on the feet, torso, hands, and head. The dark doorway and the position of the hands lend the illusion that the model is emerging from some deep cavity behind the area of untouched paper.*

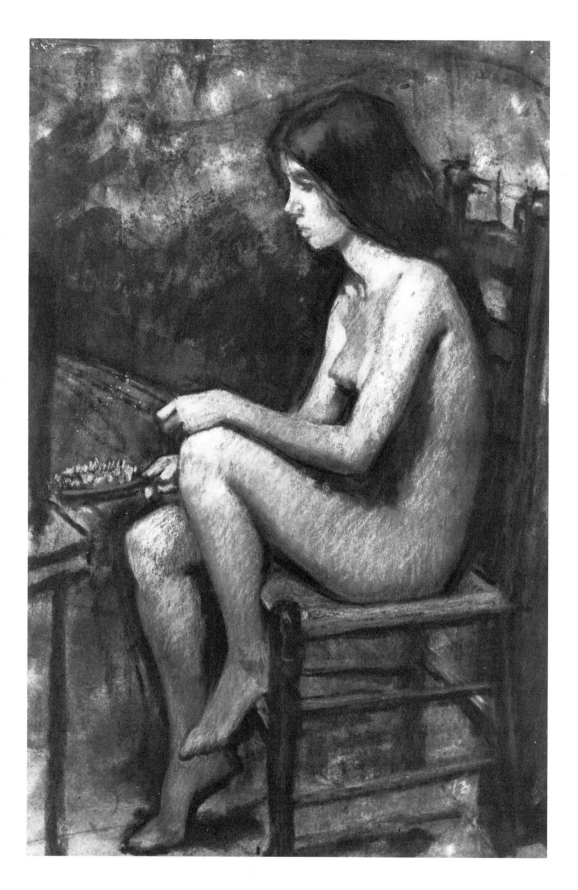

Watching Television. *Pastel on watercolor board, 12" × 9". This is a rapid study executed in a single sitting, painted against a very colorful background with some of the background colors repeated in the figure. The front of the figure reflects the lights cast by the television set.*

CONCLUSION

FRAMING
YOUR
PAINTINGS

One of the problems attending pastel paintings is the fact that they must be framed under glass to avoid smearing or other damage to the painted surface. Once they're properly framed and sealed against dirt, pastels are as permanent as paintings of any medium, but a reputation for fragility has deterred many artists from painting, and collectors from acquiring, pastels.

Some considerations regarding the protection of the pastel surface are the following:

To prevent the pastel particles from shaking loose or flaking when the painting is jarred or bumped.

When possible, to keep the pastel surface from coming in contact with the glass of the frame, thus minimizing the possibility of the pastel adhering to the glass surface.

To make allowance for the natural expansion and contraction of the paper within the frame.

To keep the painting away from damp, moist areas, preventing mildew.

Under normal conditions, such as when hanging on a moisture-free wall, a framed pastel painting is quite impervious to damage. It's primarily during the time that it's handled and transported, that extraordinary care must be exercised to avoid possible injury.

A lesser problem is the reflection of the glass under certain lighting conditions. But this is a problem also present in framed prints,

etchings, watercolors, and can be circumvented by rehanging the picture in a more advantageous position or location, or by using nonreflective glass.

Mats. Pastels have been traditionally framed with mats, but the reason for this has been primarily to separate the painting from the glass. If this is the only reason, it isn't necessary to use a mat when an unseen separator can be as easily employed. The decision as to whether or not to use a mat should be governed by purely aesthetic reasons — does it help or hinder the appearance of the total picture?

Framers usually recommend narrow frames plus mats for pastels, but the artist can judge if the inclusion of a light-toned and (usually) wide mat, will vie for the viewer's attention with the painting itself. A mat will produce many changes in the general appearance of the painting. It will enlarge its overall size and will also add a large area of another color and tone, thus exerting a very prominent effect on the key and dominance of the painting itself. Any light-toned mat that's as light or lighter than the center of interest or the highest value area in the painting will vie for attention — and win!

I consider mats an extension of the background which can add area and continue color, or produce an enclosing color contrast. My inclination is to omit mats altogether, since the frame can do these beneficial things as well.

Frames. In choosing a frame for your pastel painting, consideration must be given to the width of the molding, to its tone and color, and to its simplicity or elaborateness.

Molding. I don't subscribe to an automatic selection of a narrow molding for a pastel. If the painting is strong enough in value, it won't be dominated by an appropriately wide frame. The wider frames also provide greater strength of construction, which is necessary to support the glass and pastel painting in an inflexible way.

I try to select a molding that bears some relationship to the width of the objects in the painting. I would usually select a wide molding for a picture containing large shapes and vice versa, since a painting depicting small and delicate objects would tend to be dwarfed by a massive frame.

Tone. It's generally best not select a frame or mat that is lighter in tone than the overall key of the painting. This would tend to contrast jarringly with the visual impact of the painting itself. An alternate move is to choose a frame that's not far *tonally* removed from the key of the painting, but whose warm or cool quality serves either as a contrast or a complement to the overall tonality of the picture.

Design. The straight, clean-line quality of some moldings can repeat and be consistent with patterns in certain paintings, or can serve to draw one's eyes to the outside rectangle. Conversely, a molding that's repeatedly subdivided, can be unobtrusive in relation to a painting with large shapes, or appear too busy to fit a painting containing smaller shapes. Try a frame for its factors of size, shape, and pattern opposite to those in the painting; then test a frame that offers similarities to the overall picture design.

Glass. There are three kinds of glass used in framing pastels — picture glass, window glass, and nonreflective glass. Despite its disadvantages of imparting reflections, I prefer the common picture glass to the nonreflective type, which isn't perfectly clear and tends to cast a haze or sheen over the picture surface that detracts from the freshness and contrast of the painting.

Window glass, which is thicker and less fragile than picture glass, provides greater protection for large pastels and for those that are frequently moved or transported.

Plastic. Although plastic has been substituted for glass in pastel framing because it's lighter and not subject to breaking, it does bend, scratch, and nick very easily and has an unattractive, wavy-patterned appearance that I find unacceptable. However, it's preferable to glass if the painting must be transported excessively.

How to Frame Your Pastel Paintings. Before framing the painting, flick it sharply to dislodge any loose particles of pastel. It's better to learn beforehand just how much pastel will fall off inside the frame to avoid the necessity of cleaning and reframing. Also, it's a good idea to first trim the painting about ⅛" on each side with a single-edge razor blade so that it's slightly smaller than the glass and has a bit of room to expand within the frame.

Lay the frame face down on some flat, clean surface. Place the glass gently into the rabbet or groove of the frame. Clean the inside of the

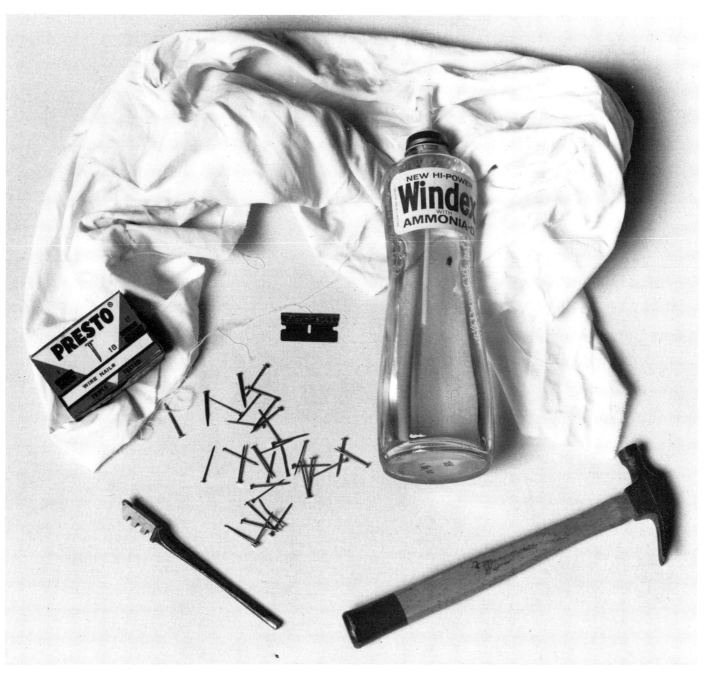

20. *Materials for framing: lint-free cloth, wire nails, single-edge razor blade, glass cleaner, glasscutter, and hammer. Not shown but needed are pliers, a matknife, and masking tape.*

glass with window cleaner, being careful not to spray any of it on your painting if its nearby. Wipe the glass clean with a lint-free cloth, then brush away any gathered dust with a soft camel hair brush.

Framing with a Mat. Lay a mat between the paper and the glass, tape the top of the paper to the mat, set it within the frame, and back it with a stiff backboard, making sure the paper doesn't buckle in the center and fall forward against the glass. The larger the paper, the greater are its chances of falling into the center of the glass. This problem doesn't exist in paintings executed on rigid boards or on papers mounted to a stiff backing. The mat used in this method of framing should be thick enough to keep the paper or board from touching the glass.

If a linen insert is used in framing a pastel painting, it can serve as a separator by inserting the glass first, *then* the linen insert behind the glass, rather than the other way around.

Framing with Wood Inserts. An alternate method to keep the paper or board from touching the glass is to glue narrow strips of wood inside the frame on all sides, where they won't show beyond the rabbet. These strips or separators will keep the painting far enough removed from the glass to prevent contact and possible smearing of the pastel. This method is ideal for framing pastels done on stiff boards, but can also be used for small works on paper. Using wood inserts as separators is easily my first choice as a framing method when at all possible.

Framing without a Mat. Another way of framing pastels is to place the painting flush against the glass without a mat. The residue of pastel that may be dislodged in this process is usually minimal. I've used this method often with success, particularly in those instances when I was concerned with the paper buckling or rippling, or in framing unmounted sheets that could possibly shift or ripple if framed under a mat.

The Floating Method. Yet another approach to framing pastels is the floating method. In this procedure, the painting is mounted to a larger sheet of paper, which forms a background border behind it. To mount the painting, you attach pieces of double-face tape to the center and top corners of the painting and background paper. The painting then hangs free within the frame, seemingly floating against the background. Care must be taken, however, to avoid tipping the top of the framed painting forward, which would result in the bottom of the paper swinging into the glass.

Passe-Partout. The *passe-partout* setup consists of a kind of sandwich made up of a stiff backboard, the picture, a mat, and the glass on top, all tightly sealed and encased on four sides with tape. This method produces an airtight, rigidly confined package which can then be fitted inside the rabbet of a frame. However, since it doesn't allow for the expansion and contraction of the paper caused by changing temperature conditions, a slight rippling of the paper can occur. Trimming the paper a fraction smaller than the glass will allow for expansion. Of course, a heavy sheet of pastel paper will ripple less, or not at all.

After you have fitted the painting and backboard into the frame (cardboard, Masonite,

plywood, or any other stiff board), nail three 1″ nails into each side of the rabbet of the frame, for a total of twelve nails in all. Make sure that the nails are *entering the rabbet straight* and aren't so angled *as to strike the glass.* Avoid any undue pressure on the backboard.

Having driven twelve nails, lift the frame and examine the front of the painting for any flecks of pastel or other foreign material caught inside the glass. If such exists, remove the nails, take out the backboard, painting, and mat, clean the glass, and repeat the framing process. If the painting is clean, drive additional nails all around, enough to insure the painting being securely held in the event of jarring. After all the nails have been driven, use 3″ wide masking tape to seal the edges of the backboard and to render the painting airtight. The front of the glass can now be recleaned with Windex, using light pressure when wiping.

Storing Unframed Pastel Paintings. The important thing in handling unframed pastels is never to allow any lateral movement which could smear the pastel. The storing of unframed pastels *can* present problems. A large, flat drawer in which the paintings lie flat, one on top of another without sliding, is particularly practical. A sheet of acetate, clean pastel paper, or glassine paper can be used to separate the paintings.

Another way to store unframed paintings is in an artist's portfolio, but here, it's better if the portifolio lies on its side. If you must store pastels standing, it's best to affix the paintings to some kind of rigid support.

A third way to store unframed pastels temporarily is to suspend them from clips nailed to a wall, or if convenient, in a clothesline-like clip arrangement.

Transporting Unframed Pastel Paintings. The difficulties of transporting unframed pastels can be minimized by covering each painting with a somewhat larger sheet of cardboard above and below and securing this sandwich with tape. If no lateral movement occurs while this cover is arranged, and if the whole package is fairly tightly held together, there should be no problems.

Shipping Framed Pastel Paintings. The key to shipping a framed pastel painting safely is to enclose it in a crate that won't permit the painting even the slightest movement. The crate must be strong, solid, and impervious to damage. Crumpled newspapers or other cushioning material must be stuffed tightly into all the empty spaces so the painting is firmly held in place and not given room to move inside the crate.

If there's more than one painting in a crate, cardboard should be tightly packed and wedged between the paintings to avoid any lateral or up-and-down movement. The screw eyes mustn't be allowed to thrust against the glass or backboard of the other paintings, and all glass must be taped diagonally so if it should break, it will remain in place. Pieces of cardboard cut to the size of the frame should be taped to the front and back of each picture to be transported.

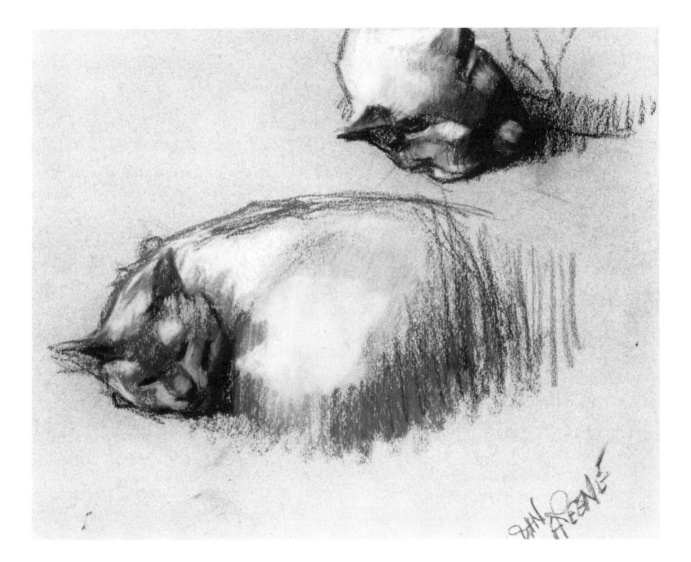

Study of Mingy — Two Heads. *Pastel on paper, 10½″ × 13½″. I prepared a dozen sheets of pastel paper to have at my immediate disposal for a new study each time the cat moved. I chose a limited palette of soft pastels and let the gray tone of the paper serve as one of the colors used. From the number of studies completed in this session, I retained six that were particularly satisfying. Pastel lends itself well to this type of rapid impression.*

BIBLIOGRAPHY

Doblin, Jay. *Perspective: A New System for Designers.* New York: Watson-Guptill Publications, 1956.

Doerner, Max. *The Materials of the Artist: And Their Use in Painting with Notes on the Techniques of the Old Masters.* New York: Harcourt Brace Jovanovich, 1949.

Laning, Edward. *Perspective for Artists.* New York: Grosset & Dunlap, Inc., and London: Pitman Publishing, 1967.

Mayer, Ralph. *The Artist's Handbook of Materials and Techniques.* New York: Viking Press, 1970.

Savage, Ernest. *Painting Landscapes in Pastel.* New York: Watson-Guptill Publications, 1971. London: Pitman Publishing, 1974.

———. *Pastels for Beginners.* New York: Watson-Guptill Publications, and London: Studio Vista, 1966.

Sears, Elinor. *Pastel Painting Step-by-Step.* New York: Watson-Guptill Publications, 1968.

Singer, Joe. *How to Paint Portraits in Pastel.* New York: Watson-Guptill Publications, 1972. London: Pitman Publishing, 1974.

White, Gwen. *Perspective: A Guide for Artists, Architects and Designers.* New York: Watson-Guptill Publications, and London: B. T. Batsford, Ltd., 1968.

INDEX

Coordinated by Claire Hardiman
Designed by Bob Fillie
Composed in 10 point Elegante by Computex Corporation
Printed and bound by Halliday Lithograph Corporation
Color printed by Sterling Lithograph